STYLING FOR INSTAGRAM

© 2018 Quarto Publishing Plc.

Library of Congress Cataloging-in-Publication Data
Available Upon Request

ISBN 978-1-250-18221-0 (trade paperback)

First U.S. Edition: January 2018

10 9 8 7 6 5 4 3 2 1

Produced by Rotovision, an imprint of the Quarto Group.

Publisher: Mark Searle
Editorial Director: Isheeta Mustafi
Commissioning Editor: Emily Angus
Editor: Abbie Sharman
Design: JC Lanaway
Cover design: Emily Portnoi and Jane Lanaway

Printed and bound in China

DEDICATION
For Richard
brilliant photographer,
even better dad

"Stop trying to get it right.
Just take the picture."
SALLY MANN

STYLING FOR INSTAGRAM

Leela Cyd

ST. MARTIN'S GRIFFIN
NEW YORK

CONTENTS

INTRODUCTION

With a phone in your hand you can be a "photographer." There's no extra buy-in fee, you already have what you need, and "auto" mode works just fine. With technology having evolved so quickly in the past decade, there's no reason not to try your hand at making beautiful images. A fancy camera is no longer necessary to make great pictures, but a creative mind still is.

I grew up with a photographer father and a writer mother. We always had visiting artists around our dinner table, and making pictures seemed to me as natural as breathing. From an early age, I understood that being a photographer/writer was a passport to an interesting life. It was also fascinating to meet the growers and creators of the subjects I photographed (thanks Mom). My job today as a photographer, author, and stylist combines all the skills and awareness I developed from a young age—a love of documenting life and making it beautiful has set me on a never-ending quest. Following my passion has not always been a straight path but it's still the motivation for all my work.

This book is a collection of tips I've gathered from a decade as a professional photographer and a lifetime of being an artist. Each chapter will give you information in an easy-to-digest, practical way. I love sharing insights that can make a big difference to your approach to photography and fill your Instagram feed with gorgeous and compelling images—it took me years to figure out some of these things! My hope is that this book will encourage you to get your phone out and begin to make seriously beautiful photographs.

#AndHaveSomeFunAlongTheWay

Summer Drinks

brekky

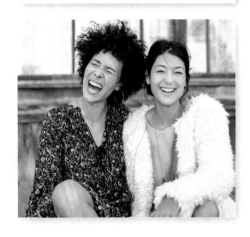

HOW TO USE THIS BOOK

This book aims to help you make simple, yet extraordinary images with your phone and to build a strong and stylish Instagram feed. You may want to make images purely as an artistic endeavor, or perhaps you're building a brand and there's a need to create content everyday—or maybe your motivation is somewhere in between. This book will help give you a repertoire of practical skills and ideas on how to build up an engaging feed with different prompts and ways of seeing and photographing your world.

You can flip through and see what catches your eye, or jet straight to the chapter that will benefit you most. Are you a shopkeeper showcasing your curated wares? The Light chapter would be a great place to start. Got the travel bug, and want to share your explorations with your friends and followers? Jump to the Places and Spaces section. Perhaps you are an artist and need some help getting started with photography, in which case, head to the Get Inspired and What to Shoot chapters.

I'm endlessly curious and fascinated by other photographers and what their creative process looks like, so I've included nine case studies featuring interviews and photos from some of my Instagram heroines and heroes. These wonderful picture makers spill all the ins and outs of how and what they think of their photography practice. Get inside their heads as they explain how they chase specific lighting patterns around their house during the late afternoon sunshine; move intuitively from project to project (don't overthink!); and wrestle with what their followers want to see versus the fun images they just feel like pushing out into the world.

... from the people you
meet, to the stories
you encounter, to the
pictures you'll create ...
I invite you to enjoy the
ride of a lifetime...

I've benefitted from their responses and I know you will too. Their images are amazing and they're creative geniuses!

You don't need an expensive studio or a fancy camera to make photos that sing, or a feed that stands out. You just need time, practice, determination, and a steadfast commitment to daily posting. There is actually no real "just" about that, but the journey is such a ridiculously gratifying one—from the people you meet, to the stories you encounter, to the pictures you'll create. I invite you to enjoy the ride of a lifetime, maybe as a new hobby or, for the lucky few, a whole new career.

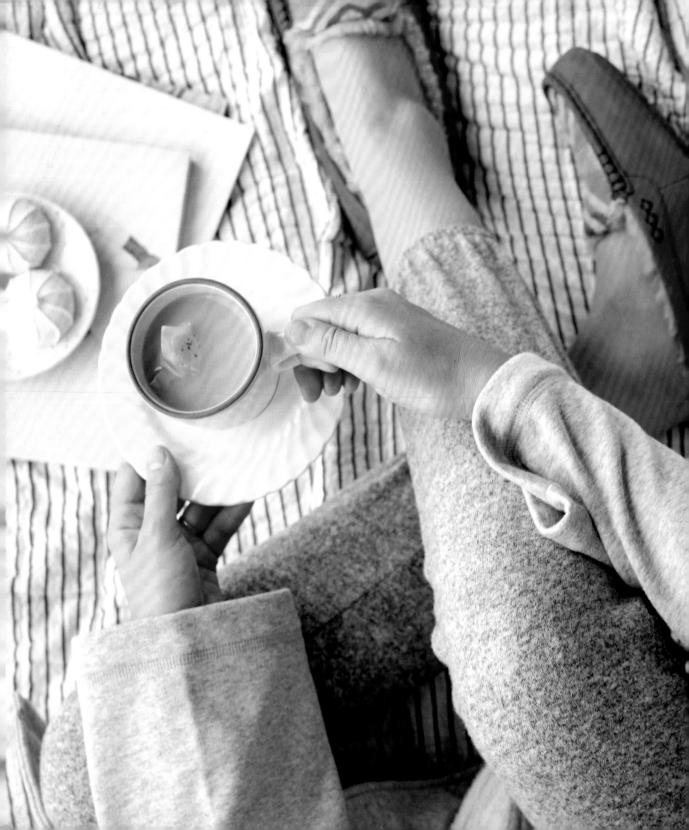

① WHERE TO START

WHAT IT TAKES

Creating a post for Instagram with your phone is no different than working with a professional camera—beautiful, well-crafted imagery still shines. Phones are now so sophisticated that technology makes everyone a great photographer, making a successful image more about an idea rather than expertise. So where to start? Here are some helpful hints to keep in mind as you share your world.

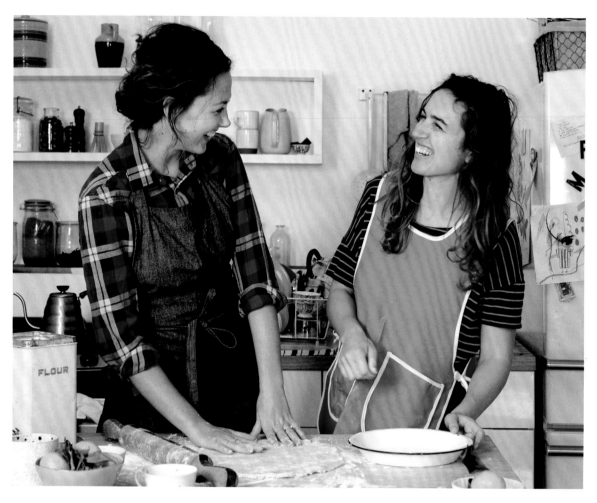

1 DON'T SHOOT IN INSTAGRAM

The camera app that comes with your phone is much sharper, offers burst mode (great for action shots) and has a grid setting, which can be helpful when experimenting with composition.

2 TRAIN YOUR WAY OF SEEING

You need to exercise your eyes just like an athlete develops their muscles for a big event. The more you notice pattern, texture, light, shadow, foreground, background, and shapes that interest you, the more practiced you will be at finding and making moments that are unique to you.

3 POST EVERYDAY

Challenge yourself to find and create an image that excites you every single day. The practice will help you improve over time, which feels great. Your feed will become an amazing visual diary and your community will grow when you set this intention.

4 DEFINE "SUCCESS" FOR YOU

Try not to worry about "hearts" and comments. Instead, create work that challenges you and expands on the ideas or style of your previous post. Ask yourself: Am I excited about this? Does this photo make me feel something? Growth, variety, and movement in your feed should be seen as a marker of success, not the external validation of followers.

5 TELL A STORY

Ultimately, a great image is all about composition and storytelling—are you creating dynamism and movement within the frame? Where is your eye drawn? Is it to the red nose or the tiara? And do you wonder just where these two are going on their bike? There are different moods for different perspectives. Experiment until you hit on the visual message that matches the story you want to tell.

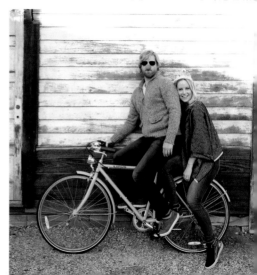

EXPERIMENT

I prefer to learn by *doing* rather than researching or pondering. Skill in photography is built through practice, experimentation, and hours logged rather than divine inspiration or natural talent. In this era where we all have a phone rather than (or maybe in addition to) a fancy manual camera, we can afford to be experimental and learn new things as we go along. Without the cost of film or software to hamper creativity, you've got nothing to lose.

① START WITH A SUBJECT YOU LOVE

Already love cooking? Food and raw ingredients can be your best muse. A fashionista? Begin with a few flat lays arranged by color or texture, or perhaps shoot details of garments in different settings. Avid gardener? Make it a daily habit to shoot the flowers that you're tending to. When you are familiar with the subject of an image you are able to see that subject in new ways and create visually interesting pictures.

② BEGIN AS A BEGINNER

Be easy on yourself. Know that it takes time to develop abilities. It can be tough to be bad at something as an adult, but give yourself room to just try, try, and try again.

③ INSTAGRAM IS A VISUAL DIARY

As you scroll through your feed, your growth as an artist becomes obvious. At first glance your images are a great record of your life, but over time your feed will reveal where you've been and where you're headed visually.

④ LEARN BY FAILING

If you're not failing at this, you're stagnating. Pushing yourself to grow creatively may feel uncomfortable, and at times frustrating, but that's okay. As you learn new ways of doing and seeing your work, your creative outlook will expand.

⑤ DON'T WORRY ABOUT PERFECTION

Moving around—physically and mentally—to create new ways of seeing and capturing images will produce an "imperfect" and non-cohesive feed (at least at the beginning of your adventure), but you will find what you are drawn to in a more authentic way than if you begin with a fully formed or fixed idea of how you are going to approach a subject. Accidents are your best friend right now.

A WAY OF SEEING

Photography is an illuminating way of seeing the world. It can be a daily meditative practice, a way to stoke your creative fire, and a chance to connect with others. I think of making images as painting with light. Having motivation and a phone in your pocket can bring immediate gratification and the ability to quickly and easily share with others. You can hone your point of view by seeing the world in terms of light and shadow, lines and composition. Practicing the way you perceive your surroundings will make you a stronger photographer. Here's how.

*I think of making images
as painting with light.*

1 NOTICE SHADOWS AND LIGHT

Tune in to different times of day. Try to shoot when your
environment looks prettiest: The breaking dawn coming
through your kitchen window and giving a glow to your cup
of tea; deep, crisp shadows thrown by a tree on the side of a
country road at midday; the last kiss of sunshine as it fades
behind the trees in your local park.

2 SUMMON YOUR SENSES

As you train your eyes to find the most beautiful lighting
and compositions, your other senses will sharpen. When I'm
photographing something I find stunning (a friend, a bouquet,
or a delicious meal), the sounds around me get punchier, the
smells more vibrant, the flavors more delicious—all because
I'm paying attention while freezing this moment in time.

3 TAKE IT SLOW

Use photography to slow down. In this modern world where
we're darting from one thing to the next, photography can be
the best incentive to rest your attention on what pleases you.
It comes down to intention. If your objective is to create a
meaningful image, take some time and pause in the moment.

4 BREAK THE ROUTINE

Creating an image can be a liberating break from day-to-day
monotony. We all struggle with routine, work, and attending
to responsibilities. For a few minutes each day, maybe more,
you can escape to a visual world—maybe an opulent lobby,
or perhaps a local park—and then share what you see with
the world.

CONNECT

When you have a phone with a built-in camera, you have the best job in the world—you are a photographer. You also have a responsibility to be bold, curious, and adventuresome. When crafting images, you have so much power—you can ask questions, discover new cultures and attitudes, explore places cut off to the casual passerby. Why? Because you have a camera and you can adopt the identity of "photographer", the modern-day explorer. Here's how.

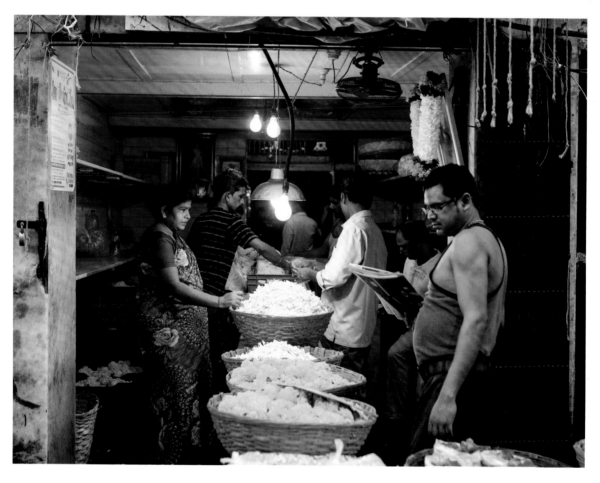

1 · BE A PHOTOJOURNALIST

If you have a blog or Instagram account, you are a content maker. You have full license to explore topics that interest you, photograph them, and then publish what you've made. This means if you're into cooking, get to know the person behind the counter at your favorite delicatessen—photograph and interview them. Love an outfit on a style maven? Ask if you can photograph her . . . she will probably be flattered. How about a craftsperson you've noticed making something beautiful while you're on holiday? Go and ask about their story and what they make—take photographs a few times during the conversation. You get the idea.

2 · CONVERSATION STARTER

The decision to "be" a photographer, even for a couple of hours, can spark conversations that leads to unimagined directions and places. I'm normally a reserved person, but when I'm in photographer mode, I take on an exuberant, extrovert personality and boldly ask questions of people I find fascinating. Most of the time, when you are taking someone's photograph, they are happy to share a little about their world and perspective. As a photographer, you have an opportunity to dig deeper into the life of a stranger or a friend and learn something new.

3 · FIND YOUR TRIBE

When you're a photographer, you have an excuse to talk to fellow photographers. No one will relate to an experience of "trying to get that shot" like another person in the field. My greatest friends are other female artists because it feels so good to be supported and understood by women with similar interests and struggles.

4 · SOCIALIZE ON SOCIAL MEDIA

Through sharing your work, you find your digital tribe. Social media makes it possible to create connections with people from all over the world. Folks whose passions align with yours will find your work, comment, and poof—a potential friend! I've met up with several online contacts made through my work and now I'm lucky enough to call them close friends.

HASHTAGS

Hashtags are the most popular means of categorization on social media.
The pound sign (#) and a word can instantly organize your image into a group
labeled with the same identification and make the photo infinitely easier to find.
Hashtags also make it easier to connect with users with whom you share common interests.
Love them or cringe at the thought of them, hashtags are part of our vernacular
(the word was added to the *Oxford English Dictionary* in 2010 and the *Scrabble Dictionary* in
2014). Here are some tips on how and when to best use hashtags with Instagram.

Love them or cringe at the thought of them, hashtags are part of our vernacular.

1 BE SPECIFIC

If you are working on connecting with your audience and other users, chose language that means something to the target audience. For example, if you are a florist, using #FloralDesign is fine, but be sure to include the type of flowers used in specific arrangements as well, such as #Geraniums #Dahlias #Roses #Delphiniums.

2 DON'T GET CARRIED AWAY

Don't use more hashtags than words in your caption. Using an endless list of hashtags is like screaming, "find me" to your audience. Keep to ten hashtags or fewer per post.

3 SHORT AND SNAPPY

Keep hashtags to a single word or concise phrase. Keep obscure phrases to a minimum if you want your tags to be discoverable. When it's easier to type, it's easier to find. As an example, #PinkFrostedCake can just be #PinkCake.

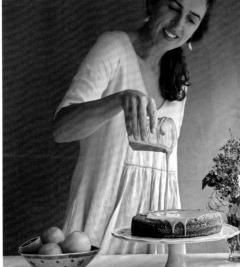

4 CAPITALIZE

Make sure your tags can be understood. If you string too many lowercase words together it makes them hard to read. The search function is not impacted by case. #toomanylowercaseletters #CapitalizationIsBetter

5 KNOW YOUR AUDIENCE

Hashtags are a great way to do some research and can show you the endless ways that other image-makers photograph the content you're drawn to. Exploring with hashtags can lead you to new feeds, as well as new phrases to use as hashtags so that you can attract like-minded people to your feed. #CopenhagenSunshine

EVERYONE'S INVITED!

For much of the twentieth century, photography was strictly for the trained craftsperson; there was magic to being in the orange glow of a darkroom and conjuring up shapes on a blank ghost of paper. It cost time and money to hone the ability to make images. Now, most of us have phones with the capacity to create stunning, high-resolution images. Becoming a photographer no longer requires an expensive "buy in" of equipment, and technology has democratized the practice, but the level of accessibility can be overwhelming. Here are some questions to ask yourself before adding to the stream.

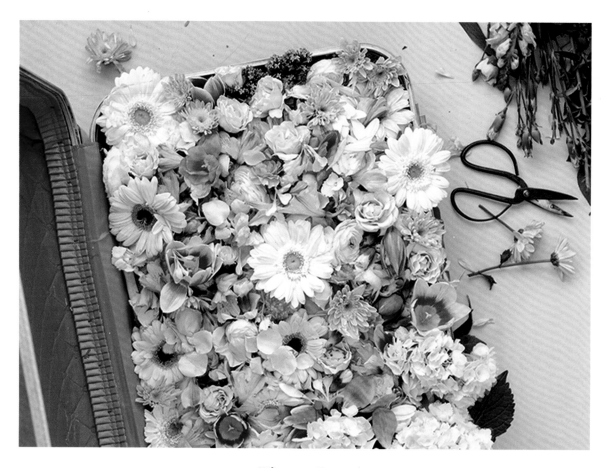

Where to Start

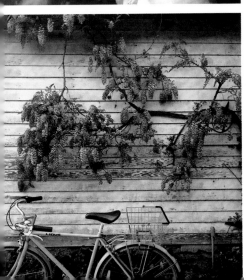

1 LOOKING VS. SEEING

We *look* at a lot of imagery every day, but we *see* few pictures. How do you make an image stand out in a deluge of visual information? What does it take to make a viewer want to linger and *listen* to your take on a macaron?

2 WHAT DRIVES YOU?

Think about the adjectives you use when describing a powerful image—monumental, pristine, white, serene. Reference those words as the starting point to finding your muse.

3 KNOW YOUR GOALS

An Instagram account is free and easy to run, but you need to be clear about how you want to use this channel, and what it is you want to say. Are you looking for a casual audience of "likes," or deeper engagement and commentary? Your images may be different for each goal.

4 CONSIDER YOUR FORMAT

Think of a phone as the default delivery medium when making your work. Shoot and adjust to ensure the image sings in this format.

Now, most of us have phones with the capacity to create stunning, high-resolution images.

FIND YOUR WAY

The wise words of Oscar Wilde, penned over a hundred years ago, still ring with meaning: "Be yourself, everyone else is already taken." Finding your own creative voice is a worthy pursuit. The Latin root of the word "voice" is *vocare*, meaning "to call, invoke." Our voice is the thing that calls out in between the "stuff" of life—the little spark in our head and heart that tells us to dig deeper and explore a topic. It is crucial to your creative development to listen and encourage this spark; it will lead you to your authentic vision and journey. Here are some ways to start.

1 JOURNAL

Each day for a month, explore your ideas and musings with a few pages scrawled in a journal. Even bullet points will do. You may find that by writing your thoughts and concepts down you become more aware of what moves you, and your ideas will rise to the top.

2 REMEMBER BEING A KID

When I was seven years old I was planning tea parties for my friends: twirling in a cute hand-me-down dress, picking flowers from the garden, making cupcakes with pink frosting, and asking my dad to take our picture. I was basically art directing and styling my life, which has now become my job and creative vocation. Start with what you loved long ago. That will point you in the right direction.

3 IF MONEY AND TIME WERE ENDLESS

What would be the first thing you'd do? I'd buy amazing art, shop for a swanky dress, and take all my friends for an extravagant meal. This list may be a dream but it is possible to infuse some of the fantasy into my everyday creative life: I can go to a museum and take pictures, window shop and document the process, and order an over-the-top dessert at a fancy hotel and photograph it. These are the anchors of my creative self: food, life, and art. What are yours?

4 TRY EVERYTHING

Be bold, creatively and practically. Don't get bogged down by the details, or focus on heavy expectations and unrealistic goals. It's better to seek out the things that move you through active trial and error than to emulate someone else's vision or confine yourself to what "should" look good.

5 OPPOSITES

When I am feeling uninspired by my creative work, I try to adopt a view that is the opposite of my usual outlook. This gets me out of my head, shifts the way I see a subject, and often leads to better work.

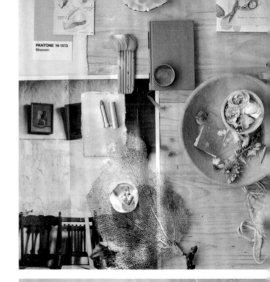
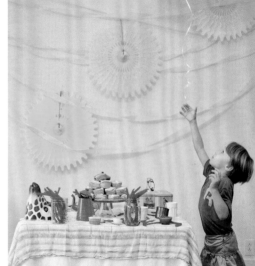

EDIT, EDIT, EDIT

It's hard to be ruthless when editing your own work, but to create a gorgeous feed you've got to be unwavering. Editing images is something a lot of photographers struggle with—we have a deep awareness of the context of each photo that makes it difficult to discard images and keep only the cream of the crop. But a cohesive flow of unified imagery creates a strong visual message. Here are a few tips on cutting the fat and picking the right images for your Instagram feed.

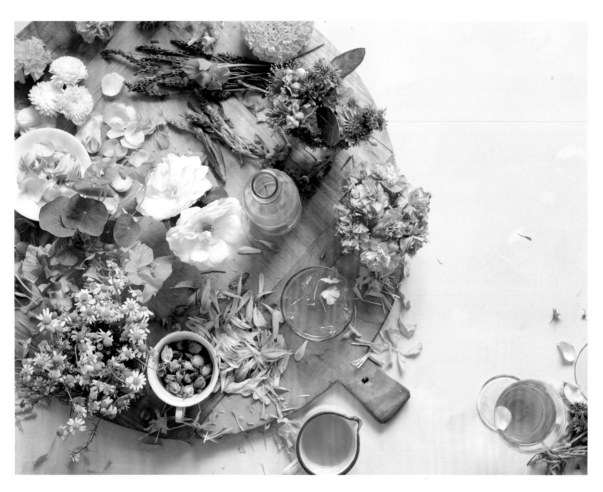

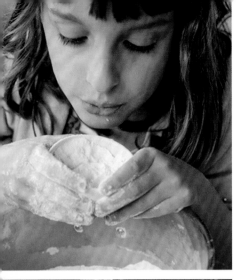

1 CONSIDER YOUR AUDIENCE

Before you start making images, you should know whom those images are for. A loosely curated private account is great for keeping friends and family up to date, for example, but if you are broadcasting content for potential clients, customers, or collaborators, it is best to stick to a specific point of view.

2 SUBJECT OR STYLE?

Stick to a single subject and don't deviate: Food, travel, portraiture, and spaces are just four topics that can be explored from a million different angles. If you take a single-theme approach, even an occasional "off-subject" image will dilute your feed. Alternatively, stick to a single style and diversify the subject. This can be a bit trickier, but is ultimately more interesting and rewarding. Decide what your overall vibe is: Bright and happy, feminine, or colorful are all possible starting points. Only publish images that fall under the category you've selected.

3 KILL YOUR DARLINGS

Not publishing something you think is great is so tough! William Faulkner said, "In writing, you must kill all your darlings." Your affection for an image that doesn't serve your objectives should never save it from being discarded. That can be a real bummer, but let that frustrated feeling sharpen your focus on creating work that serves the purpose of your feed.

4 BUILD A STASH

Create a folder on your phone of your strongest work. This way, if you're feeling restless and want to post something, you'll have a pre-edited pool to select from. You can add to this stash in your downtime between photo shoots.

5 STEP BACK

If you're on the fence about whether to post or not, take a few hours to do something else, then return to the image with fresh eyes. The impulse to press "publish" will have lessened and you will be able to assess if the image is worth publishing.

②

GET INSPIRED

DO SOME RESEARCH • COMPOSE AS YOU GO
PLAY WITH WORDS • @CANNELLEVANILLE

DO SOME RESEARCH

For inspiration on ideas, technique, and composition, I look to master artists of the past—painters, photographers, and poets all have something to teach. The lesson can be as simple as a model's gesture or pose in an old painting, or as complex as the overall philosophy and environment in which an artist was operating. Digital access to artwork in museums around the world means there's no excuse not to explore history— from the convenience of a phone, of course, in between posts.

Digital access to artwork in museums around the world means there's no excuse not to explore history.

1 START WITH YOUR FAVORITES

Do you love Caravaggio's dramatic use of chiaroscuro? Try replicating the contrast of heavy shadows and strong light in your photos. Start with your favorite artists but explore further and seek others in their canon. Use a hashtag to search for artists who fascinate you. Follow threads and leads—you never know what inspiration will be revealed.

2 SHOOT A POSE

Moved by the way a Greek sculpture of the human form is positioned and holding a gauzy fabric just so? Take a reference picture and when you're next photographing someone, direct them into a similar pose.

3 THINK CONCEPTUALLY

Explore the ways artists have addressed big concepts and look for a connection with what informs your work. Are you a modern-day feminist interested in goddess mythology? Look to the way goddesses have been portrayed in art throughout the world. Is the female form shown differently in European, Asian, American, and African art? How can you embody your point of view on these themes through photography?

4 STORYTELLING

Literature and poetry can provide beautiful inspiration for visual storytelling. I love channeling a favorite story through a photograph or series. For example, after finishing *The Secret Garden*, I created a circular composition of trinkets and curios I imagined the main character may have carried in her pocket.

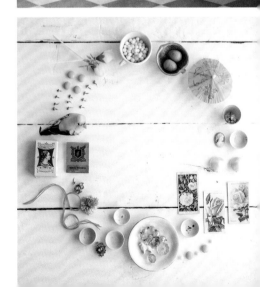

COMPOSE AS YOU GO

It's easy to move through a space blindly, following the path of a circle and finishing up where you started, without many ideas. Better to go slowly. Identify and capture themes as you consciously take your time. Any place, new or familiar, can become fascinating if you're looking for potential. Here are some tips to keep close at hand.

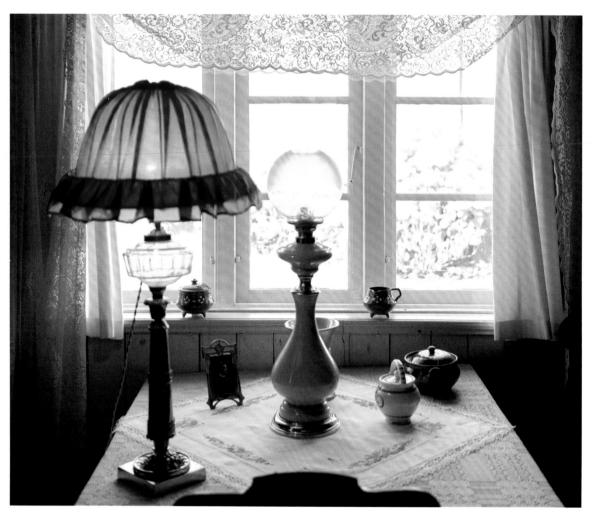

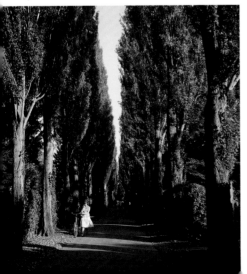

1 | BE FLEXIBLE

The way you photograph one situation may not work for another. Set yourself up and frame your image according to what's in front of you. For example, when shooting a brightly lit building interior, standing in the center of the space and facing the windows will create an airy composition. Moving very close into a sculpture in the same space, creating a single focal point (the sculpture), and letting the background fade into a blur, will give your image depth. One space, two very different approaches.

2 | IT CAN BE SIMPLE

Not everything you see needs to stay in the frame. You can edit and simplify in two ways. The first is to crop out the extraneous items and focus on the subject of your picture. For example, if there is a beautiful kitchen setup but a trash can nearby, adjust the framing until the garbage can is almost but not quite included. The second way, not always an option, is to move something that is not working with your image out of the way altogether. Perhaps if it's a light trash can, just move it out of the frame, photograph the kitchen, then put the trash can back.

3 | ROTATE YOUR ANGLE

Sometimes I get stuck shooting everything in portrait mode. It's easy to mix up your perspective and the resulting image by rotating to a landscape composition. Even if you choose to crop the image into a square, the original horizontal or portrait compositions will affect the image slightly.

4 | LOOK FOR SIGNS OF LIFE

Spaces can come alive through clues of who or what lives there. Be on the lookout for small scenes: for example, a solitary figure wheeling a bicycle along a tree-lined path can say a lot about that space and that person. If you are photographing an interesting person, look to situate them in an environment that hints at or embellishes their story.

PLAY WITH WORDS

I don't believe the artistic spirit comes down and hits you on the head every time you feel like making a picture; you need tips, tools, and ways into an engaging idea. I love to play with words as a way of coming up with unique photos. I learned this skill working as a visual-display intern while in college. Each season we created a world for two characters—their clothes, mood, style of home, vacation destination, and the music that they liked. When we had a sense of these imaginary women, we made artworks and displays that were aligned to their characters. You can do the same with photography.

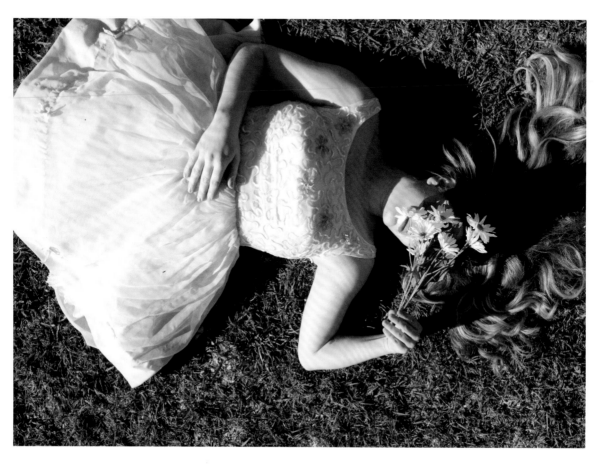

*I love to play with words
as a way of coming up
with unique photos.*

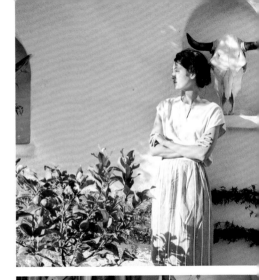

1 CHARACTER DRIVEN

Pick a character from a book, a historical figure (Georgia O'Keeffe, for example), or a friend, and use them as your muse. Create images from what you imagine their point of view to be. Would they be messy and haphazard? Strong and bold? Where would they go and how would they dress? Start with these questions and see where your mind and phone take you.

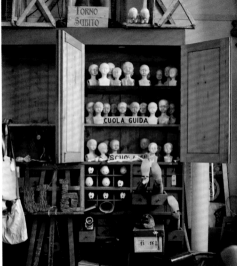

2 TAGLINES AND TITLES

Use colorful phrases from fashion magazines as a starting point. Usually, an editor has come up with a quippy phrase to describe the clothing and accessories featured in a spread. Phrases like "Road Warrior," "Dessert Vibes," "Future Tech," or "Modern Boho" all hint at fun concepts with which to frame a story and light up your imagination. Gather items you think fit into these story ideas (I love exploring second-hand stores), photograph the results, *et voila*—something fabulous may occur.

3 MAKE A VISUAL PUN

Love crosswords or jumbles? Think of all the puns you know and create an image describing them. You may have a chuckle and be the only person who gets it, but that's okay.

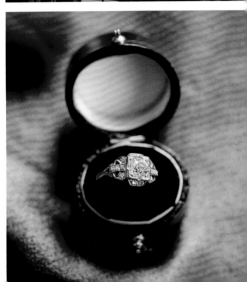

4 MUSIC

Take a favorite song or lyric as the staring point for creating an image. From Beyoncé putting a ring on it, to the Beatles in a yellow submarine—the diversity of imagery and themes explored by musical artists is vast.

@cannellevanille

Aran Goyoaga
cannellevanille.com
arangoyoaga.com
vimeo.com/user56666335

Aran Goyoaga is a Seattle-based, Basque Country born-and-raised author, food stylist, and photographer. She is the author of the book *Small Plates & Sweet Treats*, and the video series "A Cook's Remedy."

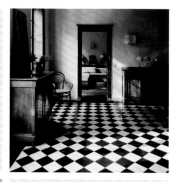

challenges

I am my biggest challenge most of the time! If what I am about to post doesn't feel true, or isn't how I want my work to represent me, I will stop myself.

tips

Cropping adds tension and helps viewers realize there is more beyond what they are seeing.

influences

Todd Hido, Ditte Isager, Juergen Teller, and Gentl and Hyers all have a very specific point of view when it comes to light.

composition

One constant across my work is very linear and symmetrical compositions; I use subtle breaks in the lines in order to add movement.

adjustments

I always meter and adjust white balance and make sure that my exposure is spot on. I always adjust contrast, too, and usually do a little sharpening.

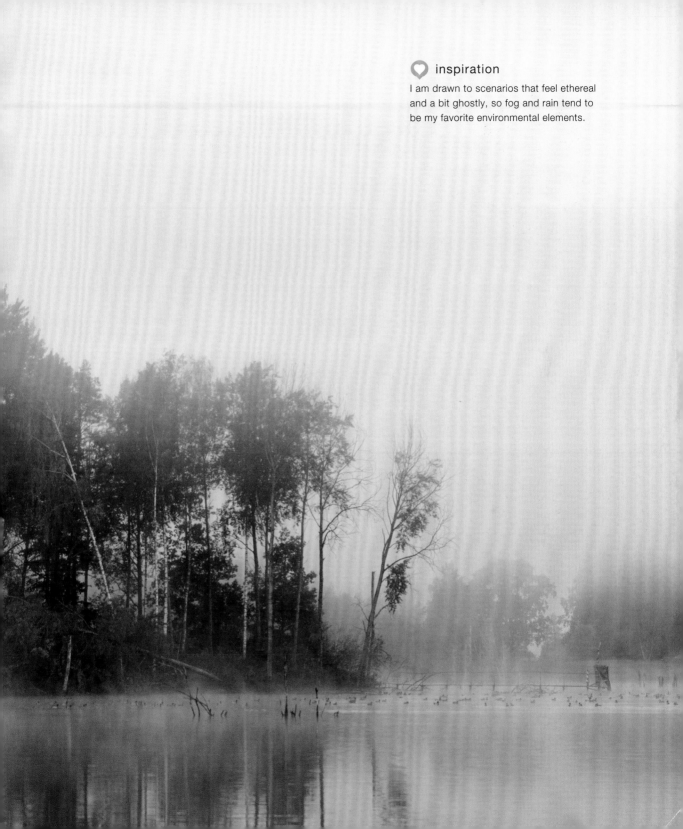

I am drawn to scenarios that feel ethereal and a bit ghostly, so fog and rain tend to be my favorite environmental elements.

③

WHAT TO SHOOT

LOOK BEFORE YOU SHOOT
FIRST IMPRESSIONS • THE CREATIVE'S HOME
COLLECTIONS • PERSONAL SPACES
ASSIGNMENT: THE TRAVEL ESSAY • @CESTMARIA

LOOK BEFORE YOU SHOOT

The most valuable time on a photo shoot is actually time spent *not* making
pictures. There's so much to be said for taking in a space before you begin,
chatting with people before pulling out your camera, or thinking about a
recipe before taking a food shot. Take a few minutes to breathe and center yourself.
What are your goals for this image-making moment? If you begin in a relaxed state,
your pictures will be better and the connection made will be more authentic
than if you start shooting as soon as you walk through the door.

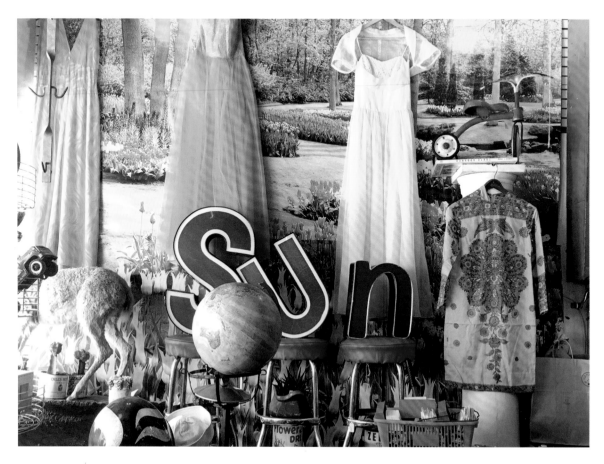

What to Shoot

1 SURVEY THE SCENE

I do a walk through of any space I'm photographing. This is either done on my own or in a twenty-minute conversation with a tour guide, or home or shop owner to understand more deeply the place I'm in. I ask which special areas they love to curl up in, or whether they have a favorite spot within their shop. Little nudges like these, and a ton of follow-up questions, can open up interesting conversations and lead you to unique images. Doors will open for you.

2 CHAT WITH SUBJECTS

Most people find it difficult to be in front of a camera. A little lighthearted chat can help subjects feel comfortable. Prepare a few questions for the person ahead of time: "How long have you lived here?," "What's your favorite part of your job?," "Do you have any pets?" are all things that I've asked when warming someone up to be in a picture. The questions can be silly (pets? Really, am I seven years old? But people *love* talking about their animals). If you are spontaneously photographing someone, compliment them and ask them a couple questions: "What brings you here?," "Where'd you get that hat?" Almost anything you say will help to break the ice.

3 LOOK BEHIND YOU

Consider this scenario: you are caught up shooting a tray of pastries, trying to get every angle possible. It's crowded in the shop, a little confusing for you. You turn around to see a parade going past on the street outside—an event that's far more fascinating than a plate of croissants. Be sure to stay loose and look behind you; the best thing on earth may be passing you by.

4 IT'S OKAY TO GO BACK

Despite planning, there will be times when you get home and realize you missed the coolest room in the museum or forgot to go outside to photograph the gorgeous chickens. You want to slap your forehead for forgetting. Don't worry about it; just go back. It happens.

FIRST IMPRESSIONS

You only get to meet a person, a place, or a beautiful object once before you become a little (or a lot) familiar. It's important to tune into the ideas and emotions that hit you immediately. Your responses to a first encounter can strike after the event, in the middle of the night, or while out and about shooting. Pay attention—these impressions can point you toward an intriguing story yet to unfold.

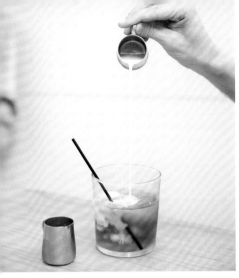

1 LUCK

One way to make the most of first impressions is to take the shot and ask questions later. Be prepared to be lucky. When you see something of interest—someone pouring milk into their drink, for example—minimize the time between that spark of inspiration and actual capture. Don't waste time looking at the image on your screen or asking for permission.

2 WRITE IT DOWN

Don't wait for inspiration to strike. Keep a pad of paper by your bed to jot things down. It's not only about having a great idea . . . but remembering the idea when you need to. Keep a running list of ideas to return to and explore.

3 FOLLOW THE SPARK

What catches your eye? Start there. Don't make it hard for yourself. Start by photographing the most captivating part of a space or the most striking feature of a person—their headscarf and bright red lipstick, for example. You can always return to the plan you thought you had.

4 PATIENCE

In contrast to the first tip, another approach is to take your time and relax in that first encounter. Compose something beautiful rather than taking the photo straight away—rearrange hats on a hat stand, place a vase of flowers on the table. Your work may exude a little more calm and a thoughtful attitude as a result.

It's important to tune into
the ideas and emotions that
hit you immediately.

THE CREATIVE'S HOME

Artists' and makers' environments have personality, humor, and tons of visual interest. The typical combination of a hodgepodge layering of artwork (traded, gifted, or made by the home owner themselves), a myriad of furniture styles, and a strong aesthetic sense coalesce into Instagram gold. The childhood home of your favorite artist or author could give you the perfect shot for an Instagram post.

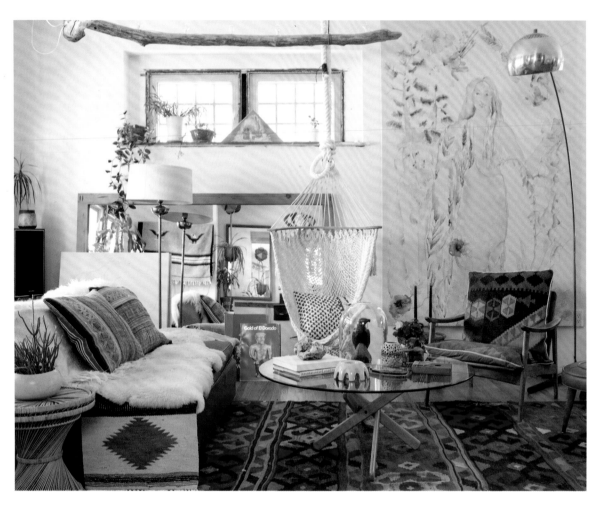

An artist's home is usually imbued with history, memory, and love.

① TIME

Give yourself more time in a creative environment than you think you'll need. This is a mantra I'm still learning after a decade of shooting creatives' homes. There is much to take in, many conversations to be shared, maybe a glass of wine or tea, and loads of images to be created. Set aside an entire morning or afternoon to dive deeply into this world.

② ECCENTRIC ELEMENTS

Interior designers look to artists and makers for inspiration. Don't worry about seeking out the "coolest" homes featured in design magazines; they can all look the same after a while. An artist's home is usually imbued with history, memory, and love through an eclectic blend of high and low style, and this combination always leads to interesting photographs. Seek out collections and the materials used to make them, then consult the tips in Collections (page 47) for ideas on how to document them.

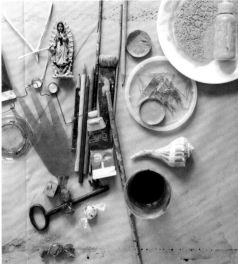

③ BEYOND THE CANVAS

No access to an artist's home? No problem—expand your view of artists to include makers and art students. Historical artists' homes (now museums) are also fabulous to explore.

④ HONE YOUR VISION

Remember to keep the principles of composition, light, and design in mind and not be overwhelmed by the layers of "stuff" and the endless possibilities. Remember you are there to create dynamic photos. Even if the home is wild and completely over the top, you are the boss of the photo; you control what the viewer sees. Make sure there is still interplay between subject, foreground and background, light and shadow, and the overall mood of the image.

◎ COLLECTIONS

Well-worn, loved curios and bits and bobs are one of my favorite subjects to photograph. They convey a sense of time and memory that is specific to their owner. A collection can sometimes tell the story of a person or a place more successfully than a portrait or a landscape shot of the location from which the little objects come. Ask to see what's in the treasure box . . . you may be surprised by what is revealed to you.

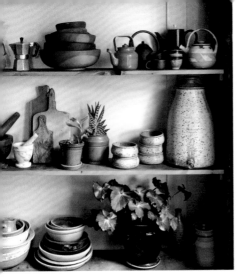

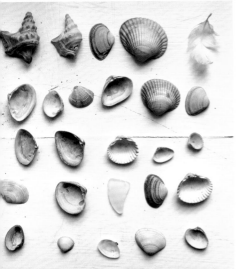

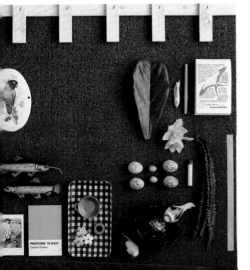

1 TELL A STORY

The collections someone makes and treasures are intimate and unique to them. They tell a story of inclinations and methodology—after all, it takes time, judgment, and focus to accumulate a collection. For example, a deeply personal, well-worn, and beloved arrangement of pottery can produce incredible shots and reveal a fascinating narrative.

2 LEARN FROM THE PROS

Look to museums for ideas on arranging collections. These institutions are the home of exquisitely curated displays of historical artifacts and natural and contemporary wonders. When you visit a museum, note the spatial arrangement of objects and try to replicate this in your next composition. Curators design displays with an eye to size, color, material, and theme to achieve harmonious compositions of seemingly disparate objects.

3 EXPLORE ARRANGEMENTS

Collections may be arranged very neatly or scattered randomly; either way, a composition made up of many little shapes makes for a fascinating image. If you feel comfortable (maybe it's your own collection of treasured shells), try varying the setup—a grid of evenly spaced items looks very different to a lovely pile or diagonal swirl of things.

4 SEEK OUT UNIQUE SURFACES

The objects you are arranging are important, but take note of the way they relate to their background. Both an "opposites attract" look (light objects on a dark surface) and a tonal approach (everything of a similar hue, including the surface) are great—just be aware of the look you want to achieve.

5 MAKE A DIGITAL SOUVENIR

Photographing a collection can be a great way to capture special objects or a themed collection without having to keep the pieces. I once created a tableau of bird-related treasures, photographed it, then simply parted ways with the objects. A print is now my visual reminder.

PERSONAL SPACES

The most visually interesting spaces are the most intimate. A precarious, imperfect, or odd home or workshop tells a rich story of the inhabitant's life. To document these zones is to invite the viewer to step inside someone else's world. Interior design magazines are full of houses that look the same—trendy, austere, and often unpopulated. A family or gaggle of roommates make a house a home; they make it real, and they can make for some very interesting photos. Here are some tips on how to capture personal spaces.

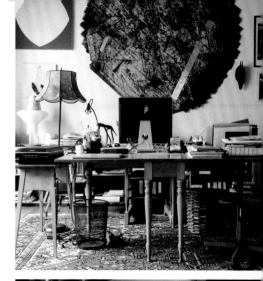

① OVERVIEW IS IMPORTANT

An establishing shot may be taken from the point in a room that gives you the broadest view of the space, or shot outside to show a home's exterior. A shot of a workspace that includes a desk, computer, and artwork helps tell the whole story of the space. Shoot horizontally or vertically, depending on the overall shape of the home—try portrait in a two-story space, landscape in a one-story home.

② DOCUMENT REAL LIFE

The personal is inviting. Seek moments that showcase the everyday life of a home—a rumpled bed rather than a perfectly tidy bedroom, or a kitchen scene with flour and a sugary mess on the counter—not an aseptic, clutter-free fiction. This is life and it's okay to show how it really looks.

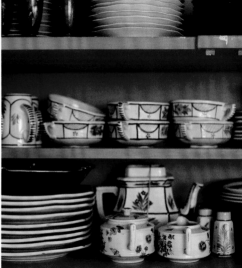

③ LOOK FOR THE LIGHT

Turn on every light in the room and photograph the scene, then study the results. Sometimes, a fixture or feature comes alive and draws the eye when flooded with light. Other times, turning off all the lights and shooting with the windows as the only light source is far more elegant. Try both ways.

④ DETAIL. DETAIL. DETAIL

Think like a stylist when you walk into a space—pay attention to the small things. Just because a TV remote control is hanging on the wall in the bedroom doesn't mean it needs to stay there for the photo. Move the prettiest cups and plates in a kitchen to the front of frame, place any dirty dishes in the sink and out of view, and if you can, take the extra seconds to wipe off a smudge. Just remember to return things to the way they were if the space isn't yours.

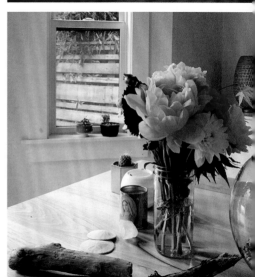

⑤ BRING FLOWERS

Flowers never fail to bring a pop of color into a space and can save a shot when nothing seems to be working. Bringing a posy of peonies and dahlias to your host's home is also a great icebreaker.

ASSIGNMENT
THE TRAVEL ESSAY

Looking to push your own creative buttons and shoot images like those in your favorite travel magazines? Compose a travel essay on your own city. Aim to create ten diverse images that fit with the style of your favorite travel magazine. This is a fun exercise to jumpstart your creativity. Here's how to get started.

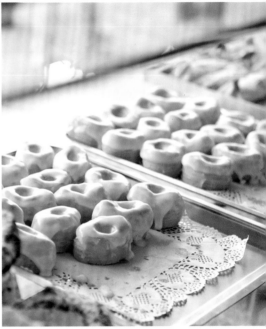

WRITE YOUR OWN BRIEF

Choose topics to give yourself a framework and make a list of the themes you want to explore. Subjects such as food, shopping, nature, art, grit, safety, and people are all useful in describing the look and feel of a place. They'd all be on the shot list of any photo editor or art director.

FIND NATURE

Get outdoors and take a hike or bike ride, stopping every half-mile to make an interesting image of what you see. Find your fellow outdoor enthusiasts and ask about their favorite trails, go down a path as a curious kid would, go slowly and compose along the way.

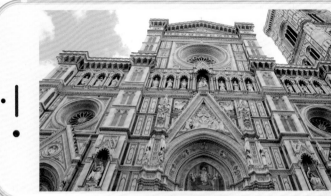

BE BOLD

Ask folks if they'd mind being in a photograph and talk to them. See what they see. How does their neighborhood influence them? Have they seen the city change much in the time they've been there? You never know where these impromptu conversations will lead. Carry a card in case they want to get in touch about the photograph. If they have really made an impression on you, get their address and send them a physical print of their image. It will cost you very little, and make their day.

TURN UPSIDE DOWN

Whenever you're feeling stuck with an image, change your position entirely. If you're shooting the same picture of the Duomo in Florence that every other person is shooting—looking up from around twenty feet away—turn your point of view around. Get on the ground and shoot from this unusual angle in order to make an image of an iconic building with an atypical and surprising quality.

@cestmaria

Marioly Vazquez
cestmaria.com

The creative mind behind Maria Marie, Marioly is a photographer and stylist living in Monterrey, Mexico. Her work is known for its unique use of color and whimsical styling.

♡ style

I loved graphic design but chose the path of photography. That is why most of my photos have a graphic element to them. I like being able to illustrate with my photography.

PANTONE®
Confetti

♡ props

I love adding little props to my images as I feel it gives them personality. My favorite props are flowers—they give a pop of color to any space or composition.

♡ color

I have always had an inclination for a pastel palette. It helps me better express myself and portray subtleness, femininity, and innocence.

♡ inspiration

My favorite season is spring. After a long winter, seeing spring's colors and light fills me with inspiration. Everything comes back to life, and that is what I like to capture.

♡ adjustments

My favorite adjustment is brightness. Although I usually shoot my images in well-lit places, I feel that this adjustment gives them a beautiful "boost of life."

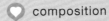
Shooting compositions can be tricky, which is why it is important to try new things. Always follow your gut and your aesthetic eye—if something doesn't feel right, try something different, but always stay true to your style.

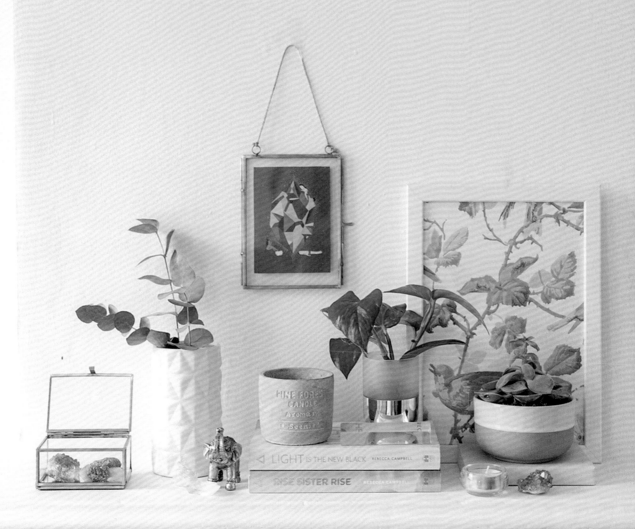

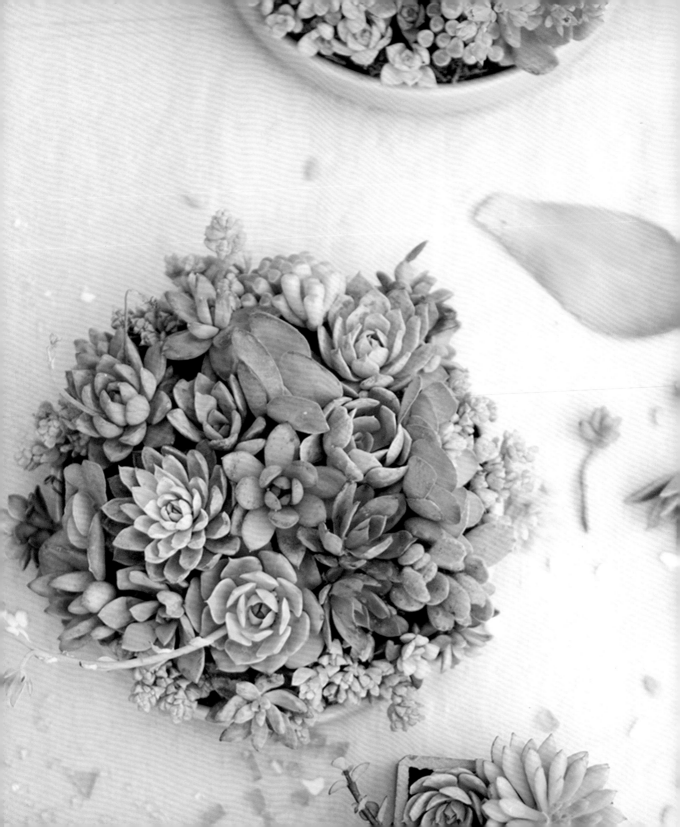

④

STYLE

DARK AND MOODY

Dark, moody images with just a hint of light and swathes of shadow have an emotional quality—melancholic, heart-achy, and wistful. There is poetry in the darkness (think Morrissey, fading bouquets, and romantic gloom). Here's how to create this atmosphere.

1 INTENSIFY SHADOWS

I added darkness and increased shadows in this bedroom scene with a piece of black foam core. (You could also use a piece of poster board painted black.) Situate your subject near a window, preferably on a foggy day, or at least in indirect light. Place the foam core opposite the light coming in and fire away. Having this dark board just out of frame will enhance the shadows of whatever you're shooting by absorbing light and preventing it from bouncing back onto the subject.

2 USE A SINGLE LIGHT SOURCE

To create a richly shadowed photo indoors, it's best to use only one light source. The most readily available light is natural light coming through a window. Turn off all other lights, position your subject (colorful roses) near the light source, and move increasingly farther away from the light. Note the change in light quality—you still want to be able to see the subject, so experiment until you have just enough light to illuminate, and no more.

3 EDIT THE MOOD

Intensify or lessen elements of an image with an editing tool or app such as VSCO or Afterlight, or in Instagram. To amp up the moody, dark tones, add shadows before posting.

4 PLAY WITH EXTREMES

Experiment with different seasons, times of day, and locations. All of these factors can add intense shadow and give a sense of a heavy atmosphere. Dawn and dusk are great times to start experimenting, as the overall light is not as intense as midday.

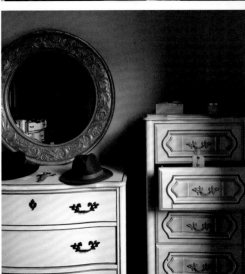

5 RESTRICT COLORS

Restrict your color palette. Having only a few colors—creams and grays, for example—can heighten the overall effect of the dark and moody style.

LIGHT AND AIRY

Want to create a sense of happiness and wistful beauty in your Instagram feed? Consider shooting with a light, airy style. Allover soft, natural light; very little, if any shadow; sometimes a soft focus; and an uncluttered composition characterize this mood. Wedding photographers, magazine covers, and many commercial outlets utilize this picture mode to embody a message of ease and joy.

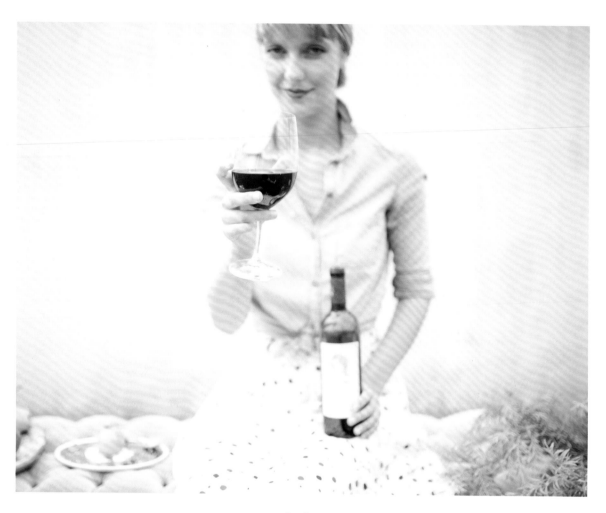

1 TRICKS OF THE TRADE

Use a white foam core to decrease shadows and amp up the lightness of an image. Place your subject near a window or outdoors in indirect light and set up a piece of white foam core (or a piece of poster board) just out of frame. The white board will reduce the shadows that fall on the side of the subject facing away from the light source. It's a very useful, inexpensive tool for adding light without turning on a light bulb, which can add an unattractive yellow hue.

2 KEEP IT CLEAN

Simplify your composition. When in doubt, take it out! That's my mantra when working in this mode. The negative space surrounding the woman on a yellow stool lets the composition "breathe," and creates an impact.

3 THE HUMAN TOUCH

When you're stuck with what you're shooting and confused as to how to change it, try adding a human hand or gesture. This can be as simple as a hand adding decoration to the food you're photographing, or having a friend walk through a table scene and bring a little movement into the image.

4 LET THE LIGHT GUIDE YOU

Utilize dawn and dusk outside, or midday when indoors. If you want soft shadows and don't have any white foam core, try shooting in the first and last couple hours of the day, when shadows are lightest. Or, if you're indoors at midday, throw open one door or window and use the indirect light to create a soft image without intense shadows.

5 GIVE THE IMAGE DEPTH

Use macro (extreme close-up) or portrait mode to increase the airy feeling by creating a little depth between subject (shoes) and background (clothes). Both of these modes help to separate a subject's detail from the environment by introducing a lovely blur.

MODERN

The current profusion of images with harsh, contrasting shadows harkens back to the early days of photography, when a still life was set up to explore the capabilities of tone—showcasing every possibility of light and dark. In art as in fashion, music, and food, everything old feels new again as the visual washing machine churns up modern versions of age-old themes. Catch onto this fun trend while it's still hot.

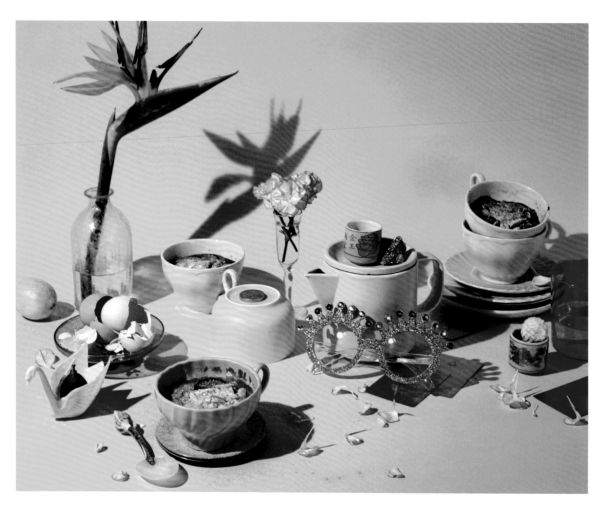

1 SHOOT IN DIRECT SUNLIGHT

To create the harsh shadows and light tones associated with this style, place your subject—a drink on a plain pink surface—in harsh sunlight during the brightest times of the day. The light is usually at its harshest at midday or in the early afternoon. Shadows will be long or short, depending on the exact time—explore both effects and see which you prefer.

2 ARTIFICIAL LIGHT

Replicate direct sunlight in a dark studio or room by employing a single direct light source. Place your subject in the middle of this light and explore the shadows and effects that the bright light creates.

3 ADD PUNCHY DETAILS

Think colorful and wild for props or surfaces—red dishes on a yellow background, for example. These little visual indicators add to the overall feeling of a modern look.

4 PLAY WITH THE FLASH

Try a flash; it can add to the "weird" factor often used in modern-look styling. I like to use a flash on a very light environment, such as an already brightly lit room or an object on a white surface, and point it at the subject. The effect is an overall lightness to the image. Give it a go!

5 TRY IT ALL

Everything you think isn't going to work might work. This style gives you the opportunity to throw caution to the wind and really do the opposite of what you think will be beautiful. Shoot from a headstand position, pick your least favorite color as your theme for the day, clear the table of all pretty food and shoot the empty glasses and plates—you get the idea. The results might astonish you.

SPEAKING IN COLOR

Colors can say a thousand things words can't—they can invoke mood, elicit emotion, or stop you in your tracks. It's amazing to think of the simple power of color. The next time you're composing an image, choose a distinctive palette and let it guide you. What do the colors say to you? What are you saying with the colors?

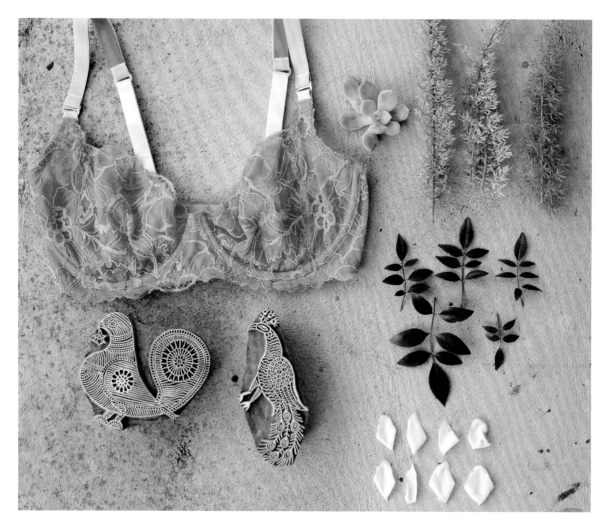

1 START WITH ONE

Choose a signature color, a color you are most drawn to. Start to note it in your everyday life—wear it, and try to locate it in other photographs. How does it make you feel when you see it? I get a rush of happiness when I see pinks—from magenta to the lightest blush, the color makes me gleeful, and has since I was a kid. Starting with a single color can show you how much can be done with one little corner of the rainbow, and is an easy avenue to a cohesive feed.

2 OPPOSITES ATTRACT

Experiment with contrasting colors and see how they emphasize or de-emphasize a subject—black and white, yellow and purple, blue and red. Note how the colored ballet slippers here vibe off each other. If you investigate basic color theory or can visualize the color wheel, just think about using colors from the opposing sides of the spectrum. They will "talk" to each other in a vibrant way that will provide a starting point.

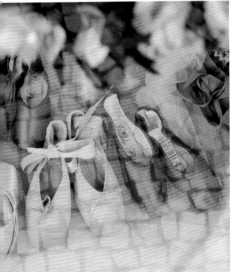

3 TONAL PLAY

Another way to dive into color is to create an image with subtle shifts in tone of one color. Think of how elegant a woman looks in a monochromatic outfit. You can apply this sophistication to pictures using a palette with barely any variation.

4 RIOT OF COLOR

Think of the joy you felt as a kid opening up a bag of candy and seeing every color of the rainbow. Or the happy thrill of looking up and seeing a multicolored string of flags while on vacation. Pure delight will radiate from an image that includes all the colors you can find.

Colors can say a thousand
things words can't.

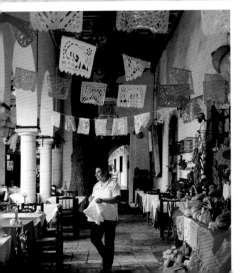

VIBE

Your vibe is everything when taking photographs—how you feel, communicate, and conduct yourself instantly sets the mood for you and your subject(s). It's normal to have a few frazzled nerves or to feel a bit excited. Taking a few deep breaths; calming yourself down, centering your intention, and plunging in with a good attitude will make the experience more fun. It will also sharpen your attention to detail, strengthen your connection to people if there's portraiture involved, and result in better images overall.

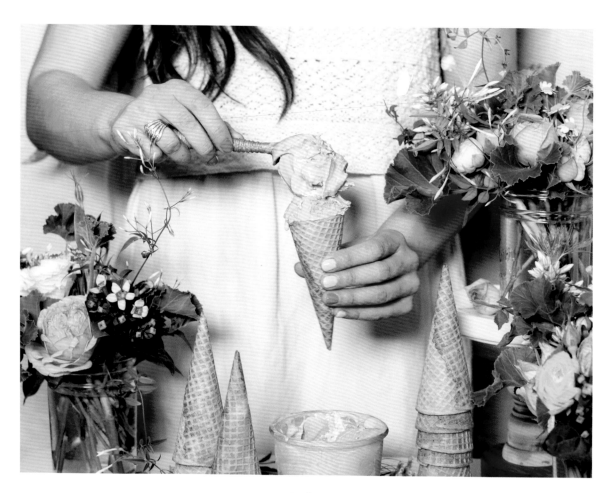

1 WEAR A POWER OUTFIT

This may seem silly but the right clothing can really put you in a good mood. When you don your "photographer" outfit—whether a cool jacket and tennis shoes, black pants and a sweater, or a particular scarf—you must feel fabulous in it. Your confidence will set the tone for a great shoot.

2 SLOW DOWN

Before, during, and after a shoot, slow down a little. I often have to remind myself of this, as I tend to move quickly through a space and a conversation. If you can go more slowly, you'll be doing the job more thoroughly, with more care, and with less room for error.

3 ASK QUESTIONS

People love to talk about themselves! As you photograph a person or move through their home, ask questions: "What's the story with the Bowie cushion?" They may respond with something that triggers a creative response in you and propels you to go deeper, connect more, and create unique images.

4 BE YOURSELF

It might sound clichéd, but if you give the people you photograph an authentic impression of who you are, they will do the same for you. Don't get too caught up in how you think a photographer is supposed to act; if you are comfortable with yourself in the space, your vision is more likely to be realized in the images.

5 POSITIVITY

If you believe your shots will work well and expect to meet interesting folks along the way to creating a few great photos, you're half way to succeeding at creating a compelling Instagram feed. A light and positive mood can buoy your photography and sense of self. When directing people, give lots of positive feedback. Saying thank you is important as well, especially if you have made a genuine connection.

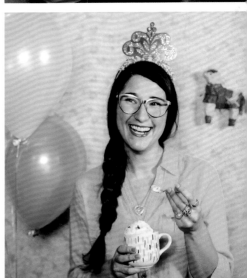

STYLING PORTRAITS

When creating a portrait, the background and environment are just as important as the figure. A simple background will help bring out the subject as the focal point; with little else in the frame, all eyes are on them. By contrast, setting your subject in a busy, natural environment can help tell their story, with objects or scenery expanding or explaining the narrative. There is a lot of room between these two extremes, so be conscious of the intent behind the creative decisions you make and the story you want your feed to tell.

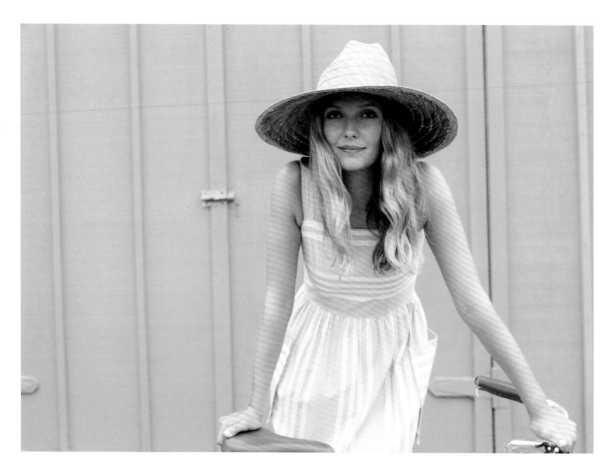

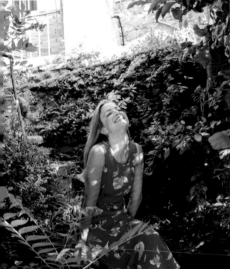

1 LOOK UP, LOOK DOWN

When entering a space that will be the setting for a portrait, take in the entire scene. Take note of what is directly in front of you (furniture, windows, trees), but don't forget the world under your feet (an ornate rug or a carpet of little flowers in the grass). As well as looking down, remember to look up—you may find a dazzling chandelier that can become part of the composition and be used to illuminate the portrait.

2 CONSIDER THE POSE

What do you notice right away about the subject of your portrait? Maybe they have a beautiful smile or outrageous hair. Make whatever captivates you instantly the focus of your image by guiding them to a pose that showcases that feature.

3 FIND THE RIGHT LIGHT

Move the lighting around. In real life, people aren't always lit directly from the front. Think about how lovely it is to be at dinner with someone and have their face aglow with light from a nearby candle, or the beauty of the dappled light and shadows you see when hanging out under a tree on a summer day. With any portrait, consider your lighting and how it complements or contrasts with your subject.

4 CAPITALIZE ON COMFORT

Creating an environmental portrait puts the subject at ease. Right away, people are going to be more comfortable in their homes or gardens rather than in front of a backdrop or in a photography studio. Use this to your advantage. Ask your subject to perform a daily task for you to shoot; this enables them to loosen up and can make for lovely, engaging images.

5 SIMPLE IS STUNNING

Sometimes, there's nothing better than a beautiful face with an intense expression. When in doubt, try sitting your subject on the floor near a window and in front of a minimal background and have a wide-ranging conversation with them in order to capture a pensive look.

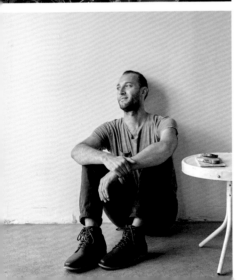

CHILL

Getting a person to relax while you're taking their picture is an art unto itself. If they are in a relaxed state, they will radiate with authenticity on camera rather than sit flat with an air of fakeness.

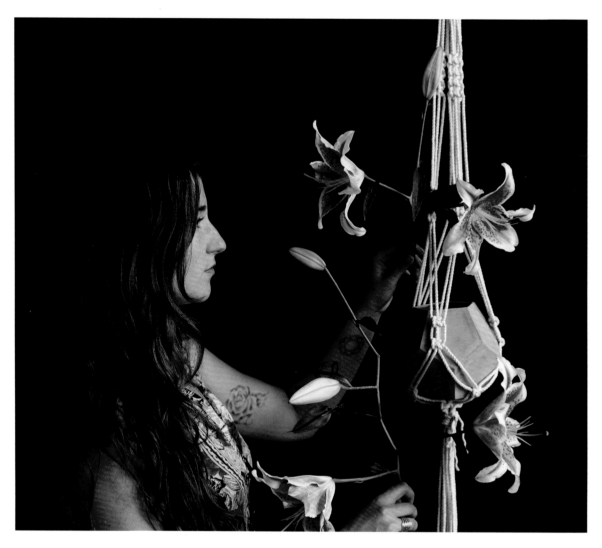

1 AMBIENCE

Set the tone with music (and/or wine). Make a playlist to get everyone in the mood for what's about to transpire. On one occasion, a lovely designer opened a bottle of white wine at the beginning of our shoot together and I'll never forget how fun and kooky we got. The pictures turned out fabulous! It's all about being comfortable.

2 COLLABORATION

Make the model a co-conspirator. I say things like, "I've been shooting a lot of people lately and there is a sameness about my portraits . . . What can *we* do that is unique? Help a sister out!" By asking the subject, they may give you a better pose than you ever could have imagined.

3 AVOID CHEESE

Don't tell people to "say cheese." If you want gorgeous photos, don't try and get folks (especially kids) to smile directly at the camera. This will only get you strained "picture faces." It's better to just interact with your subjects and fire away as you play and chat.

4 ROLE REVERSAL

Share your camera with a friend and ask them to show you a location they would use to create an image. Take turns to photograph each other. Show the portraits to each other and discuss what you like and what you might change. You are now partners in this image-making endeavor.

5 COMFORT IN NUMBERS

Photograph your subject with someone they love—a baby (or babies), friend, or a parent. You may not use this picture, but at least they will become more at ease in front of the camera. You can always ask the extra person to leave the scene (and help you to get the subject to crack up) after a few images.

HOW TO DISAPPEAR

If you are shooting an event, party, or one-time-only scene, it's crucial to have a few things lined up: the proper gear (charged phones, enough space) and the right attitude to capture Instagram-worthy shots. I find the best way to do this type of thing is to go as stealth as possible, practically disappearing. This conscious style of working yields imagery that will have your feed radiating with emotions and authentic moments.

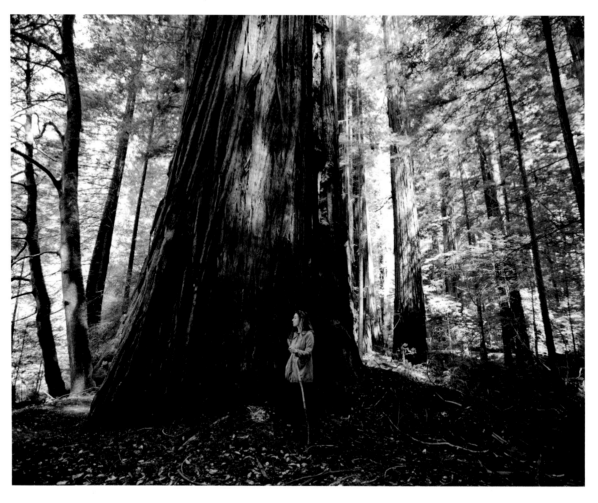

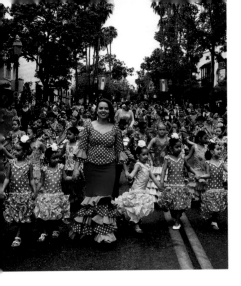

1 **KNOW THE AGENDA**
Do a little homework and find out when the event you'd like to capture is starting and get there early. Understand how the event will unfold and position yourself accordingly. Make sure you are at the right place, such as the front of the parade, at the right time.

2 **GET CLOSE**
. . . then back away. To highlight the expressive feelings of a party or even a wedding, get closer than you think is necessary. You're in photographer mode; it's okay to be a little bold. The physical closeness will be short lived and your pictures will feature a range of scale—from far away to very close. Closeness can show a gritty, raw beauty, while a more pulled-out shot can give the viewer a sense of the overall atmosphere.

3 **DIRECT (SOFTLY)**
Don't be afraid to help subjects get into a better position for a photo. They will appreciate looking beautiful later, and most people need a little guidance as to how to get there. It can be as simple as saying, "Sit up straight." It also tells people you know what you're doing, even if you don't. Encourage them with a "You're doing a great job." It never hurts.

4 **CHASE THAT SHOT**
Move your body to create the composition you want, instead of asking people to move for you. Keep moving through the space to find great images you haven't yet imagined. Don't get too comfy shooting from one spot—be fluid and rhythmic.

5 **FOLLOW EMOTIONS**
The most exciting elements to shoot at a heart-felt gathering are the emotions. If folks are smiling, laughing, or hugging, get in there quickly, photograph, and then get out of the way. I guarantee no one will even notice what you're doing, so be bold and then slyly disappear.

CHARM

How can you get folks to warm up to you in only five minutes? How do you wrap someone around your finger and get them to reveal an element of their true self so that you can capture that spirit in a portrait? This is one of the skills of photography I am most interested in improving—it is a lifetime quest. Here's what I have learned about charming someone into a great photo.

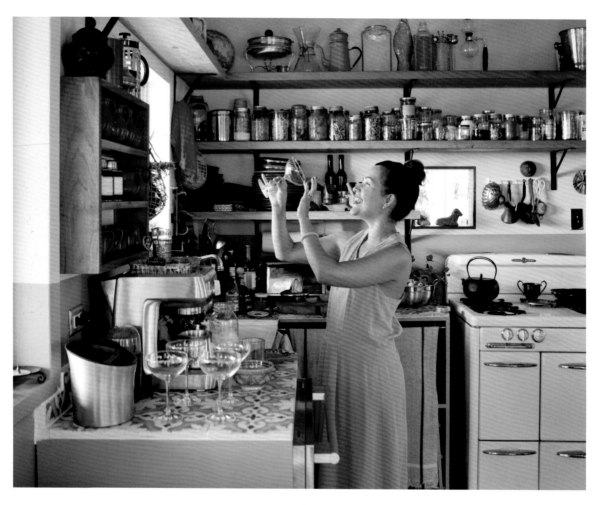

1 BE A BIT SILLY

Come up with a goofy phrase. Mine are "Work with me baby, work with me!" and "You're a tiger, you're Tony the tiger, you're great!" These are both so stupid and inane, and that's the point. Hearing these silly lines from me always starts to crack up the subject. From there, we can start really getting to know each other, and the great images follow.

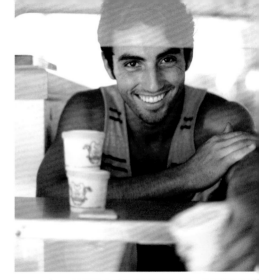

2 WARM UP

Know that your first twenty images are probably not going to be any good. The warm-up act is just that. Keep pushing the shutter button while you are saying goofy things (see above), and you'll both get more comfortable. Don't have high expectations of these first images—the good stuff is coming—allow space to get there together.

3 NOT JUST A FACE IN A FRAME

When photographing people, and kids especially, they might not always want to look at the camera, but prefer to bend down to look at a rock, or even wear a mask. There are many different ways to tell a story, and you don't always need the person's face to be front and center. Try capturing the person from different perspectives and angles. This might mean pictures of hands or feet. It makes for a very different type of portrait, but it's super interesting!

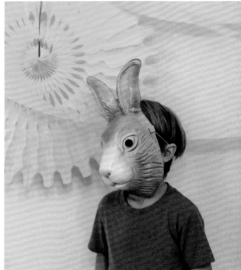

4 THE GOLDEN RULE

Never show a double chin if avoidable. This may mean shooting a bit from above or diagonally. Stand on a little step stool if you need some extra height.

5 PRINT A PICTURE

Always make sure your subject gets a copy of your image. In an age of digital photography and online feeds, having a physical print to frame or put on the fridge is a precious rarity.

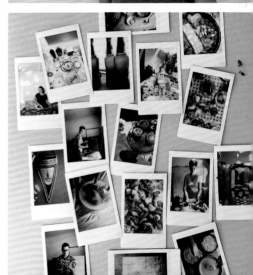

PLAY

When photographing people, having fun is not only encouraged, it's a prerequisite for creating emotive, joyful photographs. So loosen up, get weird, and don't be embarrassed to channel your inner child. Here are a few tips on how to play more while you're making pictures.

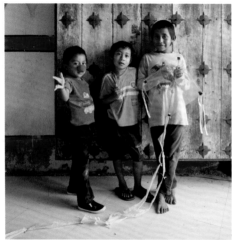

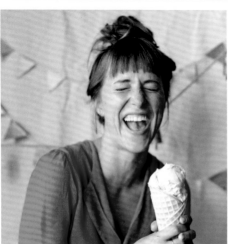

1 **HAVE SOMETHING UP YOUR SLEEVE**
Pulling out a clown nose, or dog treats are easy tricks—they seem so silly and irrelevant, but an inexpensive red rubber nose will make even the most serious of subjects double over in laughter, and the doggy treat will endear you to the dog owner forever.

2 **USE HUMOR**
Saying things like "Show me your strongest face, your sad face, your cross-eyed face, your Disney Princess face" will produce a couple of relaxed images that you can capture between and right after the subject's bursts of laughter.

3 **FAKE IT**
Fake laughs lead to real laughs. I always ask people to give me a fake laugh. It ends up being so awkward and unnatural that it inevitably turns into real laughter. It seems counterintuitive but it works!

ESSENCE

Often the person with the phone or camera takes control, telling the subject to move their head this way or that. I say, sometimes you've got to give that control up to the subject. This invites them to put a whisper of their essence on display, and allows you to capture an unguarded aspect of their spirit.

1 **GIVE THE SUBJECT CONTROL**
Ask permission before entering a personal space or touching someone's possessions. I often sit at the same level or lower than a subject so they have a physical advantage and subtle sense of control over the encounter. Use this approach and your subject will find you less threatening. This is especially important with kids.

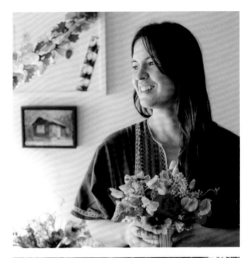

2 **MOVE CLOSER**
Once your subject is at ease, get closer than you think you need to be. Imagine someone with a camera trying to get a decent image of who you really are from fifteen feet across a room. It is difficult at best.

3 **BE NICE**
In general, people want each other to succeed. An earnest attempt at a meaningful encounter prior to and while taking photographs rubs off on the subject; they will become more themselves if they sense you are a real person with good intentions.

Ask permission before entering a personal space.

P R O P S

It can really help to have a few things stashed in a bag to help bring out humor or add a pop of color and interest to a shot. If you don't use the stuff in the bag, that's great. But if you do need a little something, you'll be glad you came prepared.

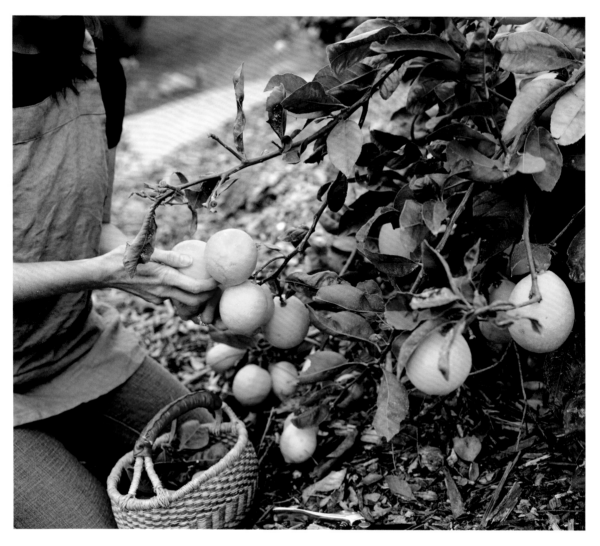

Style

If you do need a little something,
you'll be glad you came prepared.

1 TEA TOWELS

I like to have a stash of tea towels when shooting a food scene.
These cheap and cheerful props give me options; I can use one
or two as a background if the table I'm working with is just not
doing it for me, for example. It's worth having the option of
something different. Lifesaver and costs five bucks!

2 A SCARF

A colorful scarf can add vibrancy to someone's face and act
as a pop of color in a picture's plane. It can also double as a
pretty layering piece on a boring bed. If the scarf is semi-sheer,
you can use it to filter direct sunlight and produce a soft
shadow on your subject.

3 FLOWERS

Even a neighborhood bouquet picked on a walk can be
handy—you can add the flowers and foliage into a quiet,
monochromatic scene (white shoes on cream tiles); tuck
one behind your subject's ear; or decorate a tablescape
with a few petals.

4 A LIL' SOMETHING

A gesture of goodwill, such as a nice chocolate bar,
is always appreciated. If you are taking shots in a shop,
someone's home, or even a public setting, a small gift
and saying "thanks" will go a long way to let someone
know you value their time. It can also look cute in
a vignette scene or help someone warm up—who
doesn't like an unexpected nibble of chocolate?

GIVE YOURSELF A HEAD START

Setting yourself up for success is ninety percent of the work in creating a great image. You do this by considering as many factors as possible: environment, time of day, style of photo. Once you've identified what you need to bring, wear, and prepare for, you have the building blocks of a beautiful image.

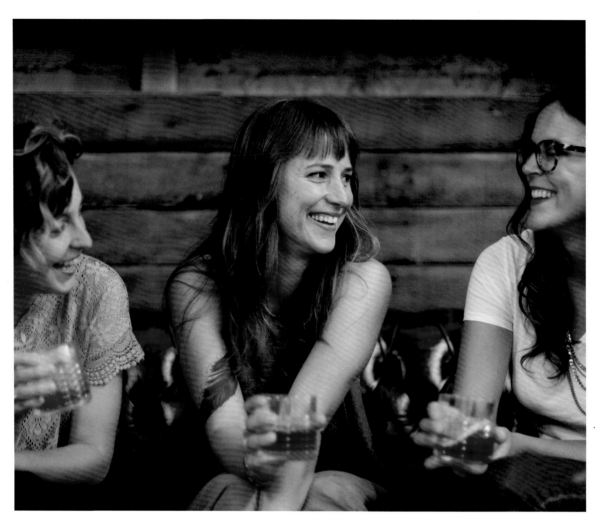

1 LOCATION, LOCATION, LOCATION

Choose the right spot to show off your subject. This can be
a local park that has a pretty garden, a colorful wall, a tidy
room in your house. Anywhere can work—the point is to keep
an ongoing list of pretty places to use for creating gorgeous
images that pop.

2 TAKE NOTES AND MAKE LISTS

Think about what you want to get out of your shots and the
story you want your Instagram feed to tell. Do some sketching
or list a few goals. You might also have a list of different shots
you want to get before you call it a wrap. Bring your notebook
with you, because mid-shoot you will forget everything!

3 ARRIVE EARLY

It never hurts to have time to take in a scene before a location
opens and fills with people. Take some shots of an empty
venue to get a sense of the light, and identify the best zone
for a photograph.

4 FLIRT A BIT

I mean this in a totally non-sexual way, but the act of chatting
up your subject, paying them a few compliments—regardless
of gender—will loosen them up and make them laugh. Now
you're ready to take their picture.

Once you've identified what you
need to bring, wear, and prepare for,
you have the building blocks of
a beautiful image.

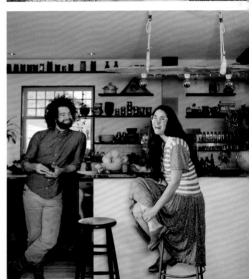

@joyarose

Joya Rose Groves
joyarose.com

© Cara Robbins

Joya Rose Groves is a lettering artist and illustrator, painting and living with her husband and daughter in their seaside home in California. After college Joya spent two years abroad, journaling and illustrating her travels, which eventually lead to embracing ink play as a career.

♡ inspiration

For the past couple of years I have focused on finding beauty in imperfection— scuffs on my boots become a patina, the mess on my workspace a pile of possibilities.

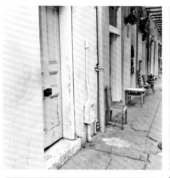

♡ props

Sometimes I just throw props in and see what happens! A perfect minimalist scene with perfectly placed details can be beautiful, but it might not always be fun. HAVE FUN!

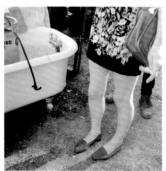

♡ styling

I used to feel like a phony arranging things just so they looked good on Instagram. Then I started working on some tabletop styling and loved it: I got over my fear of being a phony!

♡ challenge

My biggest challenge is prioritizing experiencing a beautiful place with friends and family over getting a good shot of the experience. A gorgeous online presence does not equal a rich and beautiful life!

♡ adjustments

Right now, I love to warm and brighten photos. I use a warming filter (M5 on VSCO) and brighten if needed. The trick is never to have filters on full saturation—a little goes a long way.

 favorite location

I like to take photos outdoors—any time
of year, any time of day. I love natural
textures—trees, grass, sea, wood. Also,
I have ghastly carpet in my house; maybe
my preference for the outdoors comes
from trying to avoid getting that blasted
stuff in the photo.

5

LIGHT

USING NATURAL LIGHT

To be a photographer/stylist is to be keenly aware of light, the critical ingredient in
making a subject and image come to life. Natural light, sometimes called "available light,"
is the easiest to work with, and readily available for many hours of each day. It also gives
us "the golden hour," which allows photographers to get soft, glowing shots that radiate
warmth. There is such beauty in keeping things simple and relying on available light.
Here are some tips on how best to use natural lighting and instantly improve your photos.

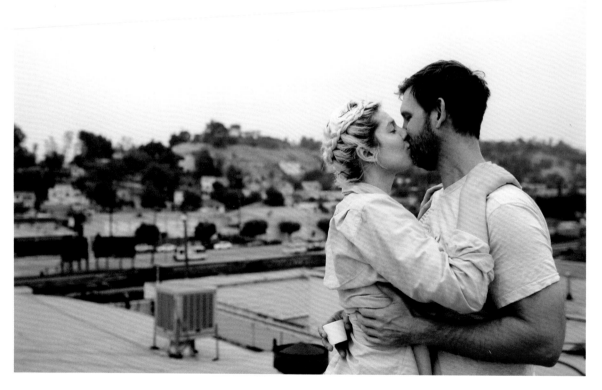

Light

1 DAWN AND DUSK

The early morning and late afternoon hours offer the softest natural light. The calm of dawn and pretty pinks of twilight are subtle and gorgeous. The absence of harsh shadows, as in the India shot, make it easier to capture a flattering image of a person, place, or object.

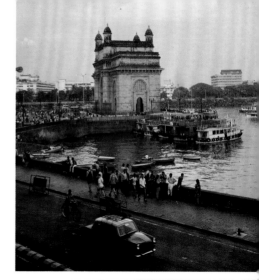

2 AVOID ARTIFICIAL

When shooting indoors, turn off all the lights—they cast a yellow shade as opposed to neutral-colored natural light that can be seen falling across the furniture and plants in this interior shot. Place the entire setup—person, object, or both—near the window to take advantage of the natural light source. If the sun is blazing through the window, put up a small white sheet or scrim to diffuse the light.

3 LEARN TO LOVE CLOUDS

Gloomy weather creates ideal lighting conditions for almost every subject. The clouds filter light in a clear, soft way and produce a beautifully subtle white light, perfect for creating evenly lit flat lays and inviting interiors.

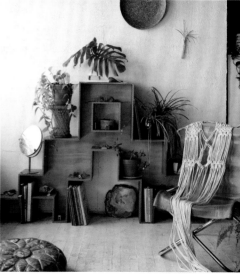

4 UNDEREXPOSURE

Focus on the brightest point of an image—a mirror or the sky, perhaps; your camera's exposure will automatically balance to the point of focus. Bring the exposure down a little from the automatic setting (this is generally done by tapping inside the frame and adjusting the brightness toggle). You can always brighten and boost the color and light within a digital image, but it's nearly impossible to recover something that's overexposed or "blown out."

5 LOOK FOR SHADE

It may seem counterintuitive to seek out some shade with all this talk of natural light, but placing your subject—ducks, people, anything—in shade and increasing the brightness after you shoot gives more control of overall exposure and avoids strong, distracting shadows.

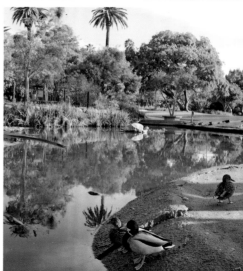

FLATTERY

Ever notice that there are a few super-photogenic people in your circle of friends—
those unicorns who know how to face the light and pose just so? Most of us are
shy in front of a camera, and are used to looking at photos and feeling "blah"
about what we see. But with a little practice and some good lighting, you
can coach your subject into a gorgeous image that you will both be happy with.

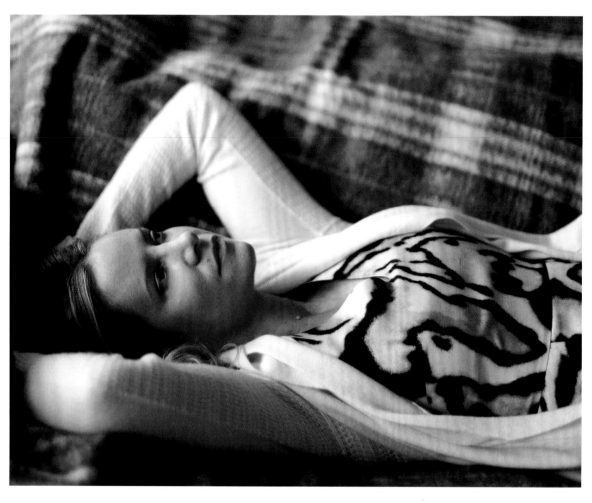

Light

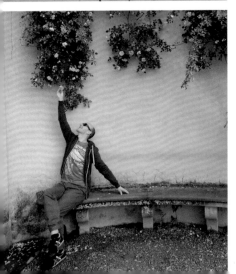

1 LET THE LIGHT SHINE

Direct the subject to face the light—it's a natural Photoshop tweak that helps eliminate furrows and creases and can reduce bags under the eyes. Use what nature provided, but don't be afraid to gently suggest that your subject powder their nose or throw on some lipstick.

2 MANIPULATE THE LIGHT

A white bounce card can help round out shadows. Use a big piece of white foam core or even a white T-shirt stretched over a piece of cardboard to bounce light into dark areas on the opposite side of the light source.

3 CONSIDER THE SUN

If you're shooting a portrait outside, keep your subject out of direct sunlight—it will cast shadows and emphasize every wrinkle and imperfection. Schedule the shoot during the "golden hour," when the soft lighting will make everyone look gorgeous and create dreamy highlights.

4 USE WHAT'S AROUND YOU

If you're shooting indoors, use a lamp or a window to direct flattering light onto the subject (just watch out for a yellow cast if using a lamp). Position the light source just outside of the frame so it illuminates the side of your subject's face. For a more direct light, position the light source in front of the subject. The light source can also be positioned so it is seen in the shot and fills the frame with light, giving the subject a radiant glow. Whatever you do, try not to have the light coming from below, which will give a spooky, Halloween look—one that is generally unflattering (except to young trick-or-treaters!)

5 BE PLAYFUL

Help your subject play, dance, smell the roses, and move around. Try to find emotion within this person—it will help him or her relax and feel a bit more confident in front of the camera, which is ultimately the most flattering look of all.

@zuckerandspice

Sam Zucker
zuckerandspicetravel.com

Sam is a freelance photographer, videographer, and food and travel writer, based in Barcelona, Spain. Originally from Boston, Massachusetts, he is also a trained chef and gastronomic–historical tour guide.

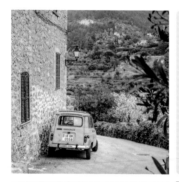

tip
Shooting into the light directly or indirectly almost always gives me a more interesting and dynamic image than one that is shot with the light source at my back.

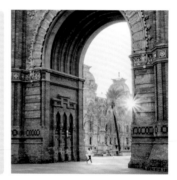

composition
I have the rule of thirds in mind often, if not always. I also frame my compositions using leading lines whenever possible. I tend not to shoot with the subject in the center of the image unless I can be sure I will have a balanced composition.

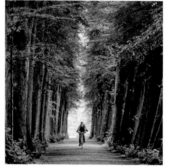

color
Vivid colors are attention-grabbing—important for driving engagement on social media. I much prefer contrast-rich, colorful photos to "washed-out" pastel or monochromatic images.

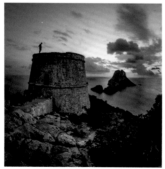

planning
Waking up early to photograph a location during the golden hour puts me in a different mood to having my camera around my neck throughout an entire day of traveling.

passions
Initially I took photos as a hobby whenever I traveled. As I started working as a professional photographer I started treating each trip as a way to showcase what I love to do. I now get paid jobs that include travel.

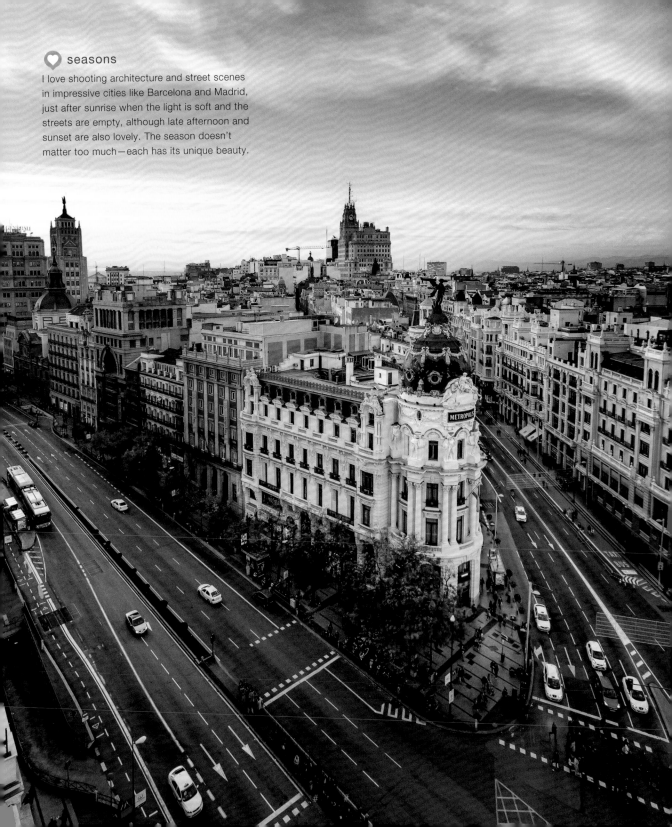

♥ seasons

I love shooting architecture and street scenes in impressive cities like Barcelona and Madrid, just after sunrise when the light is soft and the streets are empty, although late afternoon and sunset are also lovely. The season doesn't matter too much—each has its unique beauty.

LESS IS MORE

When shooting digitally, once you blow out something (overexpose an area within an image), it's gone forever. It's better to underexpose, leaving some areas a little too dark, and then lighten the image in post. This gives you more flexibility during the editing process, which is always a good thing. You can reduce the highlights in an overexposed image using the "highlight" button on the Instagram editor—just move the slider to the left until the brightness is reduced a touch.

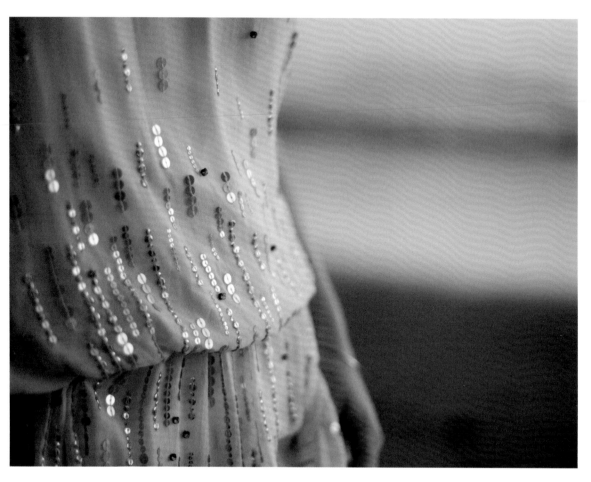

Light

> Once you blow something out,
> it's gone forever. It's better
> to underexpose.

1 EXPOSED SKIN
If you're in direct or "hard light"—during the middle of a bright day at the beach, for example—find the right exposure for the subject's skin, zoom out, and then recover highlights later.

2 HATS OFF
Hats are problematic in hard light. If your subject is wearing a hat in bright sunlight, it will create an irreversible shadow across their face, impossible to balance in post with under- or overexposure. Ask them to tip the hat back a little, wear it backward, or even play with it as a prop so that you can expose for an even pattern of light.

3 SNEAK A PEEK
Use the live view on your phone to your advantage; you can really see what you'll get this way. Try moving your focus and exposure point around by touching different areas of the picture plane on your camera screen. Note the difference when you touch the darkest, lightest, and mid points.

4 REVERSE ENGINEER
Use the shadows tool in Instagram to recover the darkest parts of the photo (shadows cast by leaves) and make more detail (flowers and sunlight on leaves) visible. By lightening the shadows, rather than using the brightness tool (which brightens indiscriminately), you'll improve the dark areas but the light parts of the image won't be altered.

THE GOLDEN HOUR

During the first two hours of sunlight (dawn) and the last two hours before the sun sets (dusk), shadows are slight and the glow of indirect light showcases highlights, mid tones, and shadows in a round, soft way. The magic of the golden hour gives everything you shoot a special radiance. So set your alarm for a dawn stroll and get out before dinner to make some heart-breakingly gorgeous images.

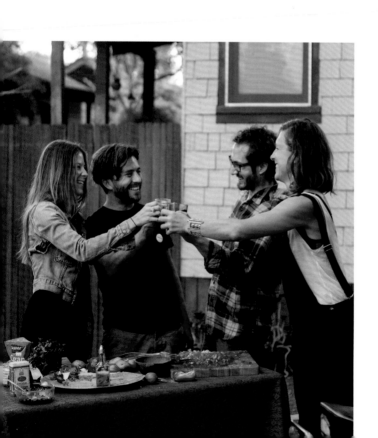

PLAN YOUR SHOOT

You've got to do a bit of homework when working with the golden hour. Go scout locations you think might work later in the day or early the next morning. Plan your composition and note any details that might be relevant later in the day. Take reference pictures, jot down notes, and return later.

NOT JUST FOR OUTSIDE

The golden hour affects the indoors, too. The light that bathes your subjects in a warm glow outside will creep through the

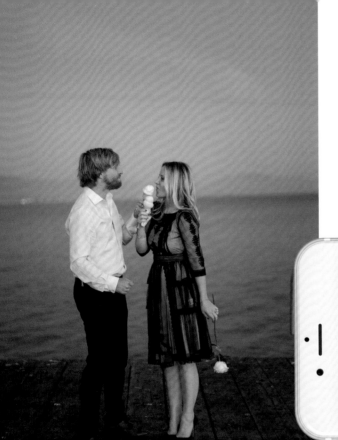

DIRECT WITH EASE
It's much easier to direct people during the first and last hours of sunlight. There is no harsh light to cause them to squint, meaning you can put them directly in front of a barely there fading or rising sun without any issue.

windows of a space. Try opening a door behind you to let in as much of the golden hour as possible, and relish in the long shadows and flattering luminosity.

KEEP AN EYE ON THE SKY
What if it's foggy or overcast? Unfortunately the golden hour is affected by clouds. Cloud cover during these times will obscure the subtle shimmer and shadows and make the overall lighting even. This is another look entirely and isn't a bad one. Just be aware of it—you may want to reschedule.

GET TO KNOW THE GOLD
The golden hour is great for lens flare, backlight, and front light. If you practice, you can really manipulate the way the soft light affects your images. Have your subject directly facing the golden light for an even, golden glow. Do the opposite and have the golden light behind your subjects, creating a subtle light all around their perimeter and a lovely golden atmosphere. If you shoot during the first or last glimmers of the golden hour, you may get a few lovely lens flares, which will add some groovy imperfection to your images.

FACE THE LIGHT

The quickest, easiest way to flatter a person with lighting is to have them face the light—
either straight on, where the light is positioned right near the camera, or from the side,
to direct light across half the face, with the other half in soft shadow. As photographers,
we are painters of light; it's the most important element of an image, so it's critical
to understand how it interacts with a person, location, or object.

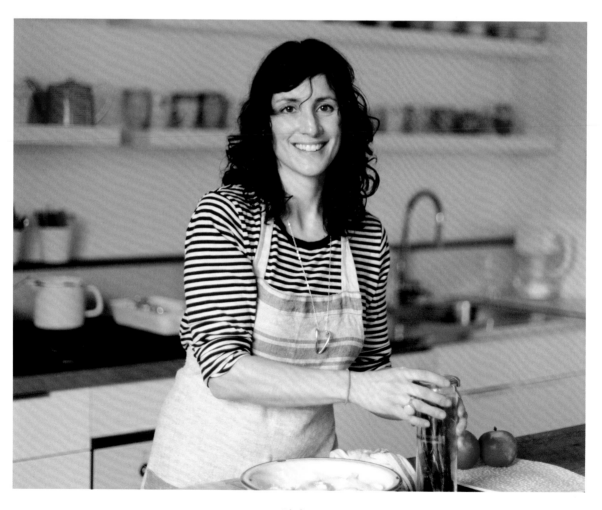

Light

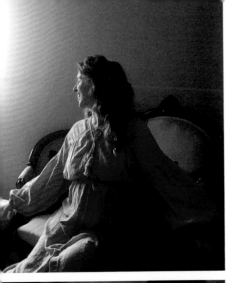

1 KNOW YOUR LIGHT

Lighting—natural, or from an artificial setup—is the best tool for bringing out all the good in someone's face and neutralizing the less attractive parts. Your photos will benefit enormously when you learn the language of light. "Photo" means "light" in Greek, and it's the core of this practice.

2 GIVE DIRECTION

With your subject facing the light, you're only half way there. Most people look better if they stick their face out a smidge from their neck and body; this creates a visual separation between face and body. It's subtle but helpful. As ever, take regular breaks and compliment your subject.

3 FIND THE BEST ANGLES

When you first meet someone whom you'd like to photograph, take note of what it is about them that immediately strikes you as distinctive and interesting. It doesn't have to be a traditionally beautiful feature—it could be a gesture, a way they hold their head, or a quirky smile. Think about ways to accentuate their unique look in a flattering, beautiful fashion.

4 SUNGLASSES

Sometimes you just can't get rid of squinting eyes, or you find that your subject looks mega-tired from the previous night's partying. When all else fails, try sunglasses. They make a lot of sense outdoors and offer an insight into the personality of the person you're photographing. Indoors they may look a little silly, but that's okay—the shot might end up being fabulous.

5 BUTTER UP

If skin is showing, use oils. For beautiful, subtle highlights, I like to ask my subject to rub some oil on any skin that's visible—apart from the face, which looks better matte, so is usually best with a light application of powder.

SHADOW PATTERNS

Vivid stripes from Venetian blinds, dappled sunlight from an overhead tree, lace patterns formed by grandmother's curtain in the kitchen window can add a thrilling element to an image. They can also be problematic, distracting the viewer from the subject. Using contrasting shadows is a purely aesthetic decision—I love the effect of strong shadow play and the dramatic feeling that it elicits. Shadows can provide visual interest, direct a viewer's attention along the picture plane, and add contrast and depth.

Light

1 KEEP TIME IN MIND
Shadows are longest around early morning and late afternoon, although this is impacted by season and latitude. Observe shadow patterns in your location if you plan on shooting a dramatic, shadow-laden look.

2 ADD SOME DRAMA
Shadows can bring an exciting element to an otherwise dull composition. Switch your focus to the shadow itself—with the subject just a sliver in the frame—and tell the story of the gesture, object, or person in an unconventional way.

3 PLAY WITH PROPORTIONS
The closer you are to the light source, the bigger your shadow will be. Experiment with shadow length, shifting both yourself and your subject's position in relation to the light source.

4 PLAY WITH PERSPECTIVE
Get above a scene to see how shadows can play a key role in a composition. I love to go to the top of a shopping mall or tall building and see how the trees or people interact with the street surface. Sometimes the beautiful shadow patterns are more interesting than the subject.

5 TAKE CONTROL
Make your own "gobo." A gobo is a dark plate with some type of perforated stencil that lets in a controlled point of light. It's an industry tool used to create specific light patterns. I often use a homemade gobo to replicate shadows found in the real world. This can be as simple as a branch of a tree held up to the light source—usually a window—to filter the light and create a dappled pattern on a basket of peaches.

@anne_parker

Anne Parker
madebyanneparker.com

Anne is a food and prop stylist based in Portland, Oregon. When not constructing beautiful tabletops, she can be found snuggled in bed watching documentaries about the 70s, adventuring with friends, and taking her time to appreciate all of life's tiny details.

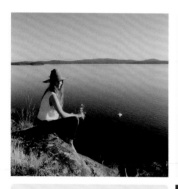

favorite

Almost every evening when I'm home, I find myself snapping photos as the sun is going down and there is a beautiful orange glow streaming through the windows. It's such a fleeting moment, but it never ceases to draw me in.

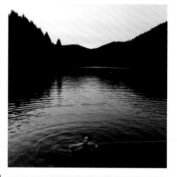

style

Oftentimes, when I look at my images I feel like they're so busy that there's too much going on. I love bold simplicity, and always have to remind myself that less is more.

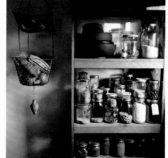

inspiration

My photography is really just capturing what I'm drawn to, and how I live in the world. In life, I always prefer dim natural lighting to artificial light, and I think that's reflected in my photos because that's the environment I'm in.

Insty-love

I'm happy to know that the content I've produced has resonated with some people. Through Instagram, people started to contact me, asking me to style photo shoots.

challenge

At first I was very specific about what I posted, and wanted every photo to be perfect. Now I sometimes post photos that I know won't get many likes. If I like what I'm doing, I'm happy.

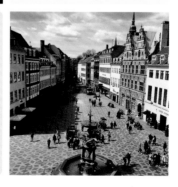

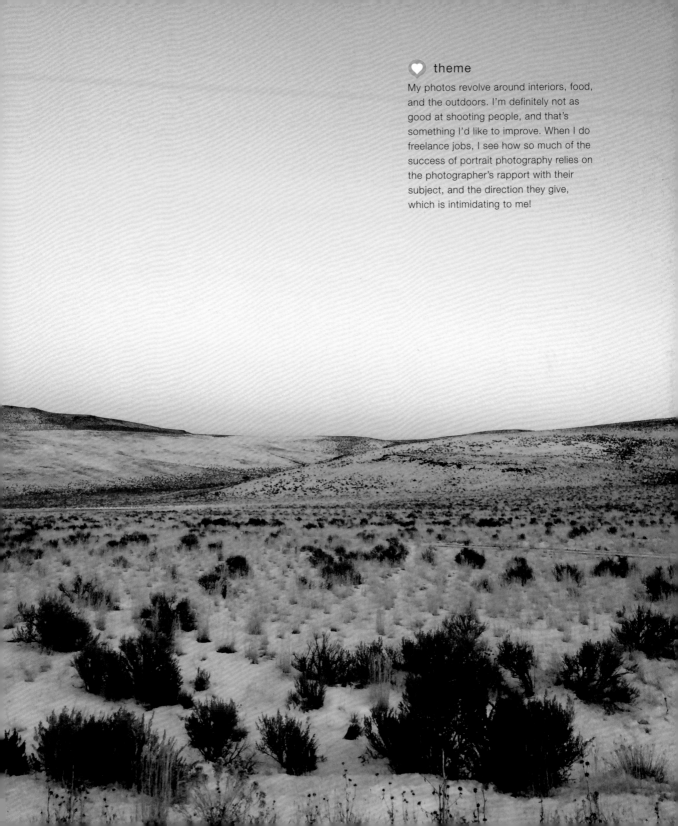

♥ theme

My photos revolve around interiors, food, and the outdoors. I'm definitely not as good at shooting people, and that's something I'd like to improve. When I do freelance jobs, I see how so much of the success of portrait photography relies on the photographer's rapport with their subject, and the direction they give, which is intimidating to me!

6

COMPOSE

OFF CENTER • EMBRACE THE NEGATIVE SPACE
STYLING FOOD • MIX IT UP • SCALE • PORTRAITS
ANGLES • POV • SHAKE THINGS UP • HANDS ON
BLENDING THE INGREDIENTS • PLAIN AND SIMPLE
LEARN YOUR LINES • WHACKY AND WONKY
CREATE A STORY • START WIDE • MESSY • MINIMAL
CREATE DEPTH • SMALL MOMENTS
@LITTLEUPSIDEDOWNCAKE • SEEING THE WHOLE
OPPOSITES POP • FLORAL • PLAYFUL
RESIST UNIFORMITY • CAPTURE EMOTION
@LATONYAYVETTE

OFF CENTER

The easiest way to create a dynamic composition, no matter which aspect ratio you're working in (square, rectangle, etc.), is to keep the subject out of the center of the frame. This approach works to make the viewer's eye dance around the image. Focusing on a subject centered in the frame will instantly pull and hold the viewer's attention to a single point.

1 BISECT THE HORIZON

A horizon defines a midline; by bisecting the frame in the bottom third or top third, you can make a livelier image. Bisecting the horizon line with, say, a church spire, gives the image openness and allows the viewer to focus on the subject. It can also provide space for the placement of text.

2 CREATE MOVEMENT

Keeping things out of the center creates movement. By placing a subject or part of a subject in the foreground or middle ground off center, you're asking the viewer to move their eye around the page, and so take the time to digest the picture.

3 SUBJECT AND SURROUNDINGS

When the subject is off center, other parts of the composition become more relevant. For example, if you're shooting outdoors, placing a big arching tree off to the side pulls the viewer's attention to other areas of the picture plane— a gorgeous sky in the background, perhaps, or a group of people hanging out at the base of the tree.

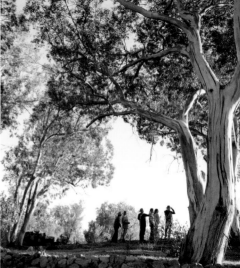

4 RULES ARE FOR BREAKING: CENTER IT!

Sometimes you've got to upend what you know and put the subject in the center of the frame. Emphasizing a particular quality of a subject (perhaps its circular shape) by placing it dead middle of the picture plane can be an effective way to amplify a message. There's an awkwardness to this style of image that can be appealing and fun.

> When the subject is off center, other parts of the composition become more relevant.

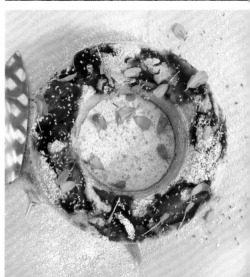

EMBRACE THE NEGATIVE SPACE

Negative space is simply the area around and between the main subjects in an image. People have been using the power of negative space since they began painting in caves. The technique is critical in all art forms: sculpture, painting, drawing, and photography. Using negative space is all about balance and creating a relationship between context and subject. Here are a few tips to keep in mind when composing an image with negative space.

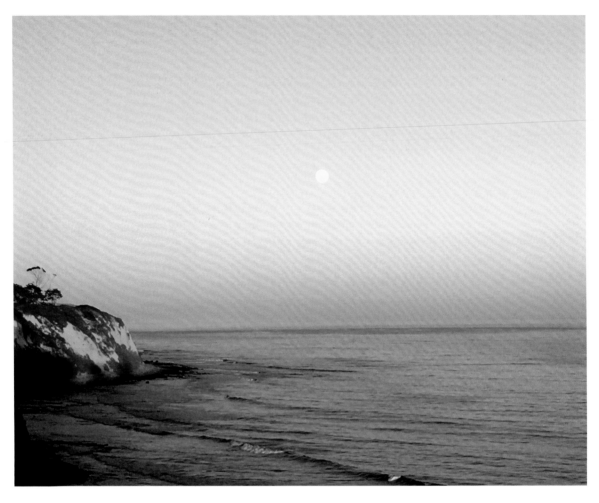

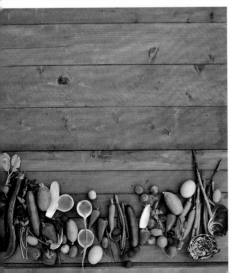

1. MOOD AND EMOTION

Negative space provides the mood, emotion, and context of an image. The setting and the space that the subject inhabits are huge factors in the story an image tells. Think of a figure positioned at the bottom of a frame, surrounded by a gray background. Now think of that same figure surrounded by a bright sky—each scene tells a very different story.

2. EMPHASIZE THE SUBJECT

The space itself can also become the subject, providing the viewer with information and context. Use negative space as an intentional feature of your composition to emphasize what's important—for example, the grandeur of a castle. Explore the emptiness and really look at all of a subject's surroundings— the spaces you originally dismiss as uninspiring may become the shapes that frame or define your image.

3. ADD MYSTERY

Negative space brings a little mystery to a composition. Think of the lilt of a piano at the beginning of a piece; it tantalizes then playfully carries you into a full sonata. Negative space is the lilt of the keys—it doesn't reveal all at once, but asks the viewer to investigate the subject and setting more carefully.

4. CROP IT LIKE IT'S HOT

You can always crop in, but can't do the reverse. I like to shoot with a lot of air and negative space in my photos. I can always decide to trim the edges and reduce the amount of negative space to make it less extreme, but it is difficult to add negative space without resorting to time-consuming post adjustments.

5. PAUSE BUTTON

The barrage of imagery we are exposed to on a daily basis is overwhelming; negative space provides a visual pause. With so many figures, shapes, and pieces of information to take in, negative space above a colorful arrangement of vegetables, for example, can provide room for a mid-scroll pause.

STYLING FOOD

If you can view food as a series of compositional elements—
colors and shapes—rather than a delicious meal, your pictures will be
stronger and more dynamic. Think like a painter rather than an eater and
view foods based on size, color, and their relationship to each other.

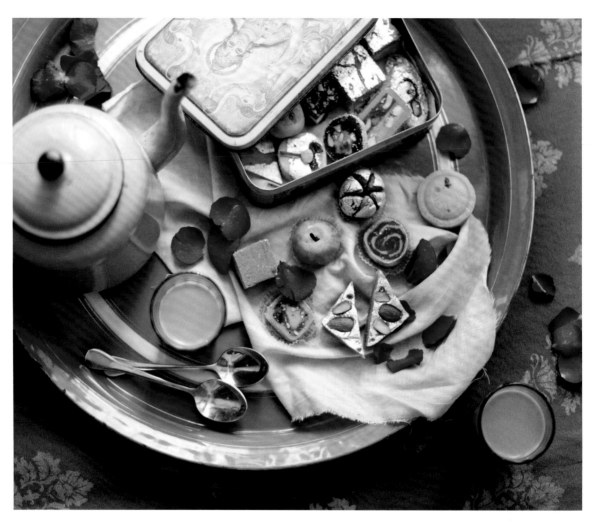

1 PLAY WITH YOUR FOOD

Rearrange. Rearrange again. Edit, remove, and then add plates or pans. Play until you see something unexpected and striking emerge. Take some time to be silly; try scattering colorful petals across a cake. Most importantly, be flexible and let go of what you think your food image should look like; something far more interesting can appear when you're experimenting.

2 NATURAL INGREDIENTS

The best food pictures start with the best-looking natural ingredients. If you have the desire to make the food you're styling, start with beautiful produce from a farmers' market; it makes all the difference. Real food looks natural, romantic, and alive—so much better than grocery store or big-box stuff.

3 TRY PATTERNS

A fun way to get out of a rut is to try lining up a series of little plates of food, a tea set, or raw produce in a square, circle, or more complex mandala shape. You can try arranging objects from small to large, in a grid, or group by shape or type of item. Just try it; you'll get something fun.

4 MULTIPLE ANGLES

It's easiest to shoot food from above, in an aerial view—this aspect flattens food and plates into a 2-D plane and emphasizes patterns and shapes. Move the setup around to see if you can find a better angle, such as super close up or straight on. Let the food you are shooting guide you, and use the shape of the food as a starting point. If a wine glass is tall and thin, you might start with a vertically aligned photo to echo the shape of the glass.

5 STYLE THE PLATE

You have control over the entirety of the picture plane. You've styled the food and plates in an overall composition—but you can also control the life happening on the plate. Watch food programs on TV to see how chefs are plating and use this as inspiration to make a statement with food.

MIX IT UP

When styling a flat lay of found objects, a product story, or a food scene, an aerial perspective is the easiest to manipulate. You can include large, medium, and small shapes in an infinite number of arrangements. From complex patterns to a sparse scattering of objects, the way you compose will help you tell the story. Use a compositional approach to create your own worlds and photograph them.

From complex patterns to a
sparse scattering of objects,
the way you compose will
help you tell the story.

1 START WITH SURFACE

The place where your objects sit is critical. A lively, green
checked textile creates one mood, while a whitewashed table
will give you an entirely different look. Whatever you choose
as a surface, pay attention to the way it interacts with what
you place on it, and use this interplay to build a visual story.

2 THREE DIFFERENT-SIZED SHAPES

When setting a table or arrangement of any kind, including
at least three different shapes of varying sizes—a teapot, a
sprig of berries, and a large platter; a shoe, a hair pin, and a
single flower—instantly creates an interesting composition
and infuses the picture with flow and dynamism.

3 SPARKLE WITH DETAILS

I love to include small flowers, stones, or candles to light up
pieces in an arrangement. These small compositional gestures
can make the scene pop and dance like little sparkles in
viewers' eyes.

4 WOW ELEMENT

Everyone loves something unexpected that makes them gasp
with glee. A pop of color or an unexpected shape—a sparkly
necklace, a trace of lipstick on the rim of a glass, a slice of
cake, a handwritten note, a vintage coffee tin—adds an
element of interest and can take an image from fun to
fabulous. Whatever the surprising component, place it
in the shot at the last moment; this trick can often work
to bring a composition together in a new way.

SCALE

Varying the scale of your photos—from extremely close up to very far away—
is key to keeping your shooting style fluid and your images varied. You don't want
to miss a detail because you're busy only shooting skies, or vice versa. Stay nimble
and physical as you move through a shoot. Sometimes photography feels like a sport,
so be ready to move your body as you vary the space between you and your subject.

1 SHOT LIST

Having a mental running list of differently scaled shots—from extremely tight to very far and everything in between—will fill your Instagram feed with a diverse body of work. Something always looks better from a certain point of view (unknown before you begin), and covering all these bases will help you arrive at the best shot.

2 OUT OF SCALE

Placing subjects out of scale can be thought provoking and sometimes funny. The disparity of a baby wearing an adult's glasses is hilarious, memorable. Getting very close up can produce a minimalist image, where line, shape, and form become elemental and elegant.

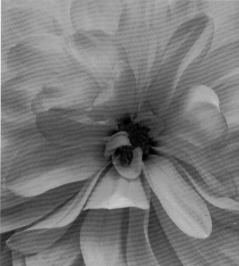

3 MINIATURES

Small is charming—seek it out when you can. I grew up with a love for dollhouses and the tiny worlds I could create within them. When you see a small object, pick it up—maybe it's a blossom or shells found on a beach walk. Learn to be a miniature-treasure collector and document your finds as if they were twenty times their size—sometimes an object can take on new interpretations, depending on how close in you photograph it.

4 BIG, MEDIUM, LITTLE

In landscape images, scale becomes critical. I love to have small things in the foreground, such as wildflowers or a moving tree branch; this way the viewer "goes through" a porthole of sorts and meanders to the back of the image, where the hills and horizons meet again. The play of shape and scale adds movement, story, and interest to the image.

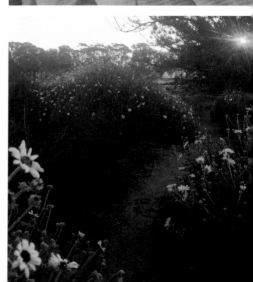

PORTRAITS

Anyone can make a picture of a person that looks like it came out of a college or high school yearbook. But how do you create a portrait that hints at a subject's inner world? Placing someone in their natural setting (known as an environmental portrait), or shooting in close up with little background, are both stylistic decisions that can be used to highlight aspects of a person's character.

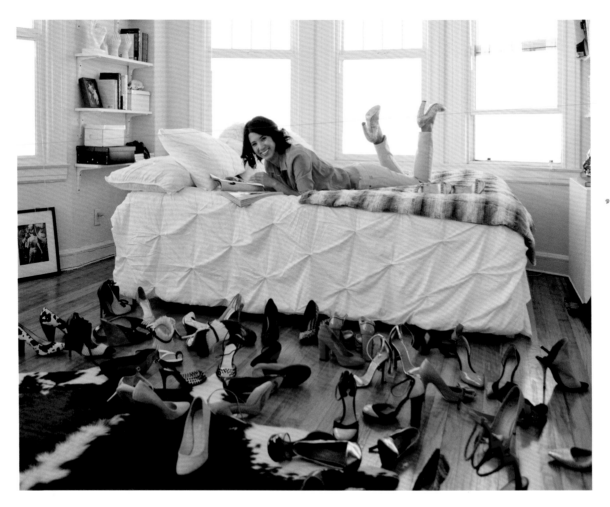

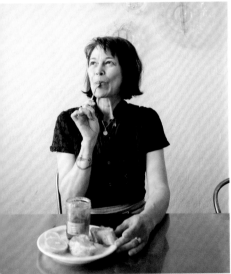

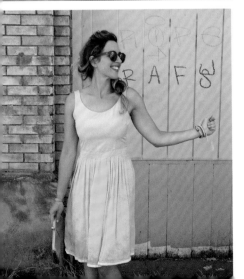

1 FOCUS ON THE EYES

Everything in a portrait can be soft except the eyes. If the eyes are out of focus, the whole picture looks off. Tap your phone's screen at the eye area, or focus on the eyes with your camera every time you take a shot, just to be sure that the eyes are clearly captured.

2 BURST MODE

There will always be times when you find the perfect angle, with sunlight falling in a spectacular way, and your subject's eyes are closed. To avoid missing the moment, shoot a burst of three or five shots. Review the shots and keep only the good ones. Be ruthless—your storage settings will thank you.

3 TAKE CHARGE

"Focus on the ceiling, look toward the window, try your hands in your pockets, how about gesturing toward me, now taste a spoonful of the marmalade, what's your plan this summer?" These are all questions and directions I have used to bring something new out of a subject. Grabbing a subject's attention and showing them you have the situation under control lets them know you are in charge and puts them at ease. Directing and asking questions will help build a relationship between you and your subject and help produce a portfolio of varied images for your feed.

4 TRY BOSSINESS

If you don't have great chemistry (it happens every now and again) then try authority. Be assertive; tell your subject where to go, show them how to stand, and make them move: "Turn this way, turn that way." You have little to lose, and you want to get the perfect shot.

5 BE IN A PICTURE

Every now and again, I like to have my picture taken. It reminds me of how awkward it can be and how it takes time to get comfortable with a photographer. It's humbling to be in front of the camera and feel uneasy—do it every now and again to be able to connect with your subjects more readily.

ANGLES

Like a sharp lawyer, I love the knowing the angles. Angles are intersections of line or shape—they're where things come together. These compositional moments are not exclusively austere, man-made, or architectural. They also occur in nature: an angle can be found in the curve of a winding stream or a sweeping branch.

Look at the intersections of things and see where they lead.

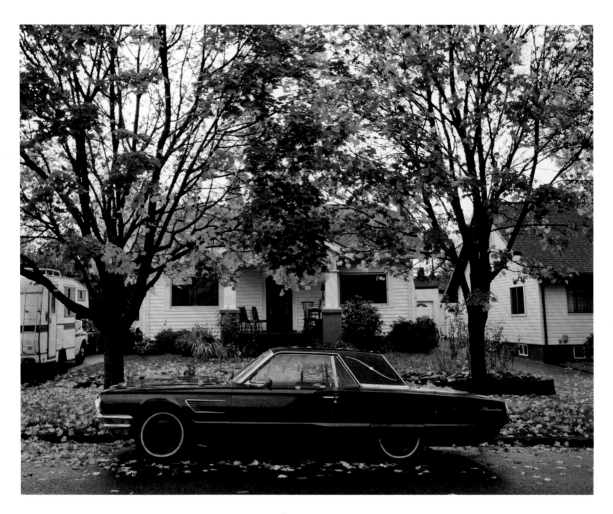

*An angle can be found in the
curve of a winding stream
or a sweeping branch.*

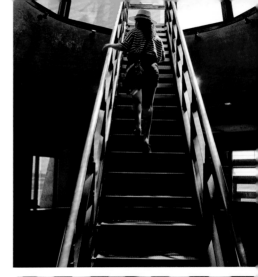

1 PERSPECTIVE

The horizon has two-point perspective—objects appear
smaller on each side of a single viewpoint. The convergence
of a staircase at a distance is one-point perspective. The best
way to learn how to use perspective is make a small lesson for
yourself: "Play the angles." Try shooting a series of one- and
two-point perspective images, and note how they affect the
feel of your final image.

2 NO SHARP ANGLES

The flip side of looking for straight angles is to seek situations
or objects where they are altogether absent. Everybody loves
the soft, pure, puffy roundness of a baby's feet.

3 MANY ELEMENTS, SINGLE FRAME

There are a multitude of in-between angles—from the
softness of puppy paws to the harsh separation between
skyscraper and sky. Try combining the two opposites. It
gets exciting when you find severe angles within a soft
environment—for example, the chubby legs of a baby, so
close they are unrecognizable, or the severity of soft birds
on a single power line. Angles when mixed with different
textures, tones, and colors become shapes. Shapes become
paintings, and then you are on your way to becoming an artist.

4 INTERSECTION

Picture a room where two walls meet bathed in natural
light—one wall will be brighter than the other. This already
creates an interesting lighting pattern, but position a person
in that intersection and you've got a thing going on, where
one half of their face will be in shadow, the other brightly lit.

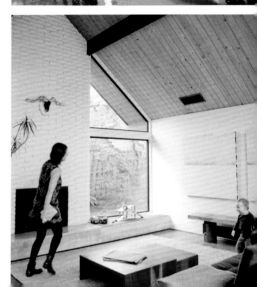

POV

Point of view is literally the position you put the camera in when viewing a scene, and more abstractly, your personal taste and style expressed through photography. It can be malleable, but over time consistent threads will start to emerge in your work. Just when you think you've got your POV down, push yourself to shift it to keep your your Instagram feed engaging, and your creativity on its toes.

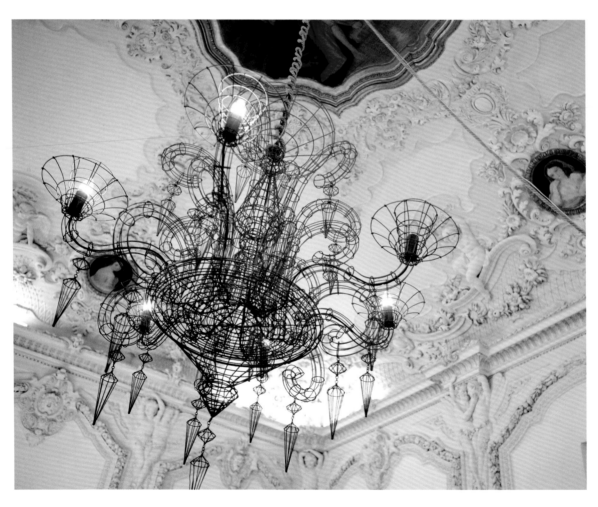

1 HORIZONTAL VS. VERTICAL

When the world of image making was filtered through the lens of an SLR camera, everyone thought in horizontal alignment. Cameras in cell phones have shifted this mindset to the vertical. If you are used to making horizontal images, change to vertical, or vice versa. Your eye level often defines point of view. It is the most expected vantage point. When you shoot from somewhere other than eye level—down low, for example—you are rearranging everything. So do not simply put the camera up to eye level; be a cowgirl or cowboy and shoot from the hip.

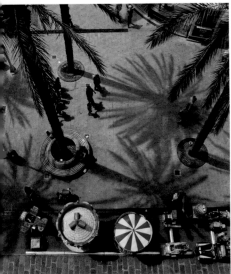

2 AERIAL

Understanding the range of POVs available to you is useful for furthering the point of your image. Aerial shots (a bird's eye view) can be taken from an airplane to shoot a valley below, or from a balcony for a new perspective of a street scene. Taking the subject's POV by shooting from eye level gives the viewer the sense that they are part of the subject's environment, not looking down on it. Making pictures from the ground is a sort of "worm's eye view" and can make everything appear larger.

3 LITERAL POINT OF VIEW

It can be interesting to shoot from right above a subject's shoulder, and include a trace of the side of their face, a lock of hair, or their hands in the frame. The viewer will "become" that subject when the image is created from this angle. We want to embody that person, we see what is shown—it's a slim amount of information, but it can say so much.

4 SEEK YOUR POV

I love bright color—I'm drawn to colorful scenes over and over again, so my point of view involves a happy, jolly palette. Because I know that's a strong part of my point of view, I'm constantly trying to refine my understanding and mastery of color—studying the way certain shades vibe with one another, and how subtle shifts in color can create a very different feeling to that produced by strong clashes of, say, bright pink and yellow against pastel green.

SHAKE THINGS UP

Often the limitations you have are self-imposed. Get rid of them.
Don't be afraid to *take* a picture or *make* a picture. Give yourself the
power to try something different. Be unpredictable. Success can be a terrible
mistress, lulling you into believing that you have the answers, and making you fear
stepping away from what has worked before. When you think something doesn't
work, try to correct it by doing what you know works, then try exactly the opposite.

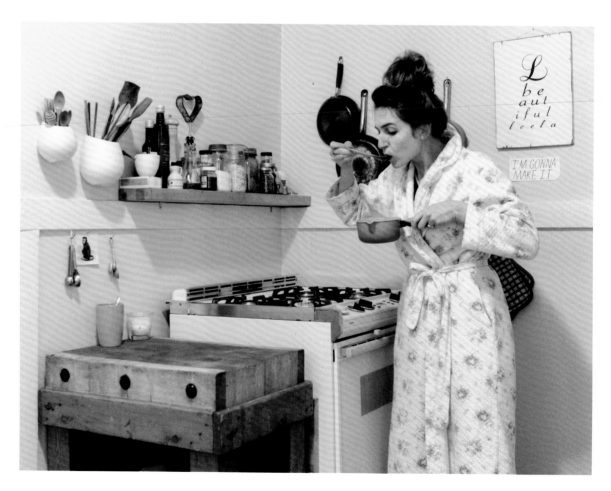

1 WHAT IS UNEXPECTED?

Disregard any "rules" you know: the rule of thirds, the "don't put things in the center" rule, the "start with natural light" idea. Throw out your notions of what you do and how you do it, and you'll start surprising yourself.

2 CHANGE YOUR PERSPECTIVE

The same subject shot from three different angles can become three entirely different images. A bamboo forest shot straight-on looks like a series of vertical lines meeting a blue sky. Shot from ground level looking up, the view is mostly of the canes with light patches of sky. If you were to shoot directly above the bamboo, the picture plane would be filled with green color and texture. Try varying the perspective on any subject to shake things up.

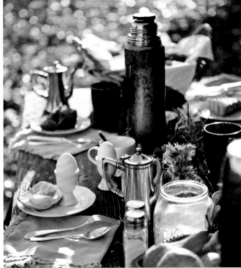

3 CHANGE THE STYLE

When you find yourself relying on a single way of seeing to compose your photographs, it's time to change things up. If your default setting is a "bright and airy" style with a single point of focus and very little shadow, make your next picture all about heavy contrast with piercing highlights and near-black shadows. The same subject will take on an entirely different feeling when you change the lighting and style.

4 START WITH ONE THING

When I get stuck and in a creative rut, or the options for creating an image become over- or underwhelming, I just start with one thing. I take a seasonal fruit, a collection of thrifted silverwear and kitchen utensils, or a small bouquet of flowers I picked on the way to the studio, and I try to make the best photograph of that one thing that I can. From there, the light or the way the little items move or interact with the background colors . . . all of it leads me to the next thing. So instead of stressing and not getting started, just simplify, then carry on.

HANDS ON

A simple gesture—a flick of the wrist, or a gentle grasp—can do so much to convey feeling and mood. When you're stuck on how to proceed with a portrait, zoom in on what the hands are doing. If they're doing nothing, ask your subject to casually put their hand on their face, run a hand through their hair, or touch the brim of their hat.

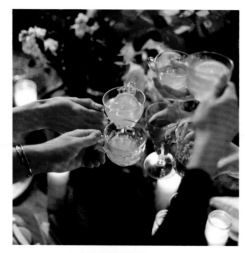

1 ADD MOVEMENT

Hands are not often still. Even if your subject is seated in the middle of a stark room their hands may be moving through a range of subtly different positions. This motion and expression of body language can permeate the entire picture. Try asking them to put their hands in their pockets, or encourage them to use their hands while telling you about their day.

2 ADD LIFE

When shooting a still life, or a travel or food story, I like to shoot a version as is, and a version with hands in it. When we see only a model's hands and not the rest of their body, we imagine the hands as our own, which leads us to be more connected to the image.

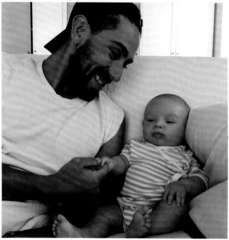

3 CONNECTION

Clasped hands instantly convey a sense of connection. If the hands are those of two people intertwined, we know they're close—maybe they're family, lovers, or friends. No matter what the relationship, it is always an intimate act that resonates on camera.

BLENDING THE INGREDIENTS

The figure-to-ground relationship—the relationship between subject and background—is the most important compositional concept you can master. Paying attention to the entire picture plane, not only the subject, produces visually harmonious and integrated images.

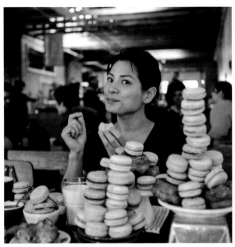

1 ATMOSPHERIC CONDITIONS

The easiest way to find a subject and a ground with very different colors is to make pictures outside the brightest points of the day. Wake up early and make your shooting time between five and eight in the morning, then go out again after five in the evening.

2 LIGHTS AND DARKS

Having a broad range of color and tone will help define a subject against a background. The subject or an area near it is usually illuminated, and the rest of the picture plane is typically in medium tones or shadow. The light falling on or near the subject—on towers of brightly colored macarons, for example— tells the eye where to look.

3 ANYTHING CAN BE THE SUBJECT

A road, an object, a room, or a single light beam can be the "figure" in your composition. While our first inclination is to start with people, push yourself to look beyond this first impulse to find the natural subject line of a room—it could be a chair, a crack in the wall, the angle at which two walls come together, or a shaft of light falling through a window.

PLAIN AND SIMPLE

To create anything that is simple and stunning requires skill and practice. Think of tasting the best bread and butter of your life; it's not a complicated dish, nor is it expensive, but when it's right, it is sublime. The elements that combine to produce the perfect baguette— bread, water, salt, and yeast—have to be flawless. The rise and the baking require a refined skill that takes years to master. In photography, your ingredients are light and rudimentary shapes, and the skill is in manipulating the composition to create feeling within an image. Simple is not easy, but it's worth trying. Here are some strategies to consider.

> In photography, your ingredients are light and rudimentary shapes.

(1) INSPIRING PHOTOGRAPHERS

Ralph Gibson is one of my favorites. His books *Days at Sea* and *The Somnambulist* are great. The black-and-white photographs show simple relationships between subjects like a hand, a shadow, sand, and the sky. Rarely are there more than three physical objects or elements in an image.

(2) VISUAL HAIKU

Seek the special within the mundane. Note how light comes through a door or casts a shadow on the wall, or how a friend's hair is illuminated by an overhead light as she exits the car. See what you discover when you seek out the simplest of subjects and compositions.

(3) SYMMETRY VS. ASYMMETRY

The simpler the symmetry, the greater its impact in a photograph. Try your composition in different ways. For example, if you're shooting a flower, get tight in and show the strong, repeating lines of the overlapping petals. Then zoom out a tad and reveal the whole bloom centered in the frame with almost no negative space. Which is better? Both can work, they're just different.

(4) SIMPLICITY IS STUNNING

When photographing people, start with a simple, stunning image. A single figure against a dark wall, without context, can be super-striking. It may take more effort on your part to relax and engage your subject when working in such an intimate setting, but it's worth a shot.

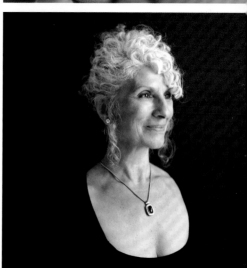

LEARN YOUR LINES

When shooting architecture or interiors, be aware of the horizontal lines
(the base of a building or room, and the tables or windows within it) and vertical
lines (where two walls come together, furniture, a building's height). When these two
things are out of whack and off axis, because they are tilted or warped, an image
tends to look unprofessional. There are a few helpful tips that can jumpstart your
understanding of this concept and give your images polish.

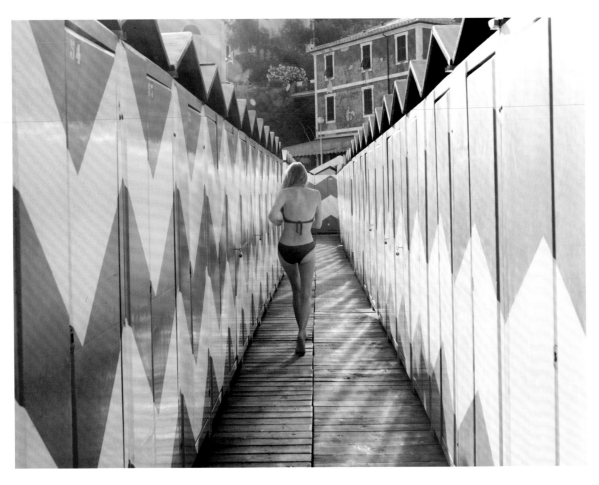

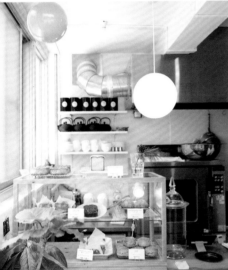

1 GRID IT UP

The grid function on your phone or camera will make it easier to keep compositions straight. Vertical lines converge when you are looking up or down. The eye naturally corrects for this effect, removing the warp of perspective, but the camera does not. When shooting interiors this can result in tall items converging to create a visually uncomfortable effect. Using the grid function will help you isolate and align the area you want to shoot straight.

2 PERSPECTIVE

An architectural drawing is a beautiful example of a 3-D object (a building) flattened into a 2-D object (a drawing). Studying these drawings can help you to identify where on the horizontal and vertical axes straight lines occur—awnings, floor tiles, counters. Being able to identify the straight lines will help you stand in the best position to capture them.

3 FIX IT AFTER THE FACT

If an image is a little skewed, you can edit to straighten the lines using a lens correction filter or the rotate tool, rotating the image slightly. Making this adjustment will crop off some of the image, so be aware of this.

4 THROW AWAY THE RULES

Don't worry about keeping lines plumb and true—get weird, forget the "right way" and see how a marina scene or any space looks from a diagonal, intentionally warped angle. What do you get? Do you like it? Two of my favorite photographers, Todd Selby and Garance Doré, embrace this off-kilter look to brilliant effect.

Being able to identify the straight lines will help you stand in the best position to capture them.

WHACKY AND WONKY

It's fabulous to be off-balance and strange, rather than straight and formulaic. Learn the rules, abide by the rules, then throw them out the window and try for the opposite effect. Aim to visually unhinge your viewer. Get low, get high up—shoot from under the table and obscure most of the image with a dark blur (the underside of said table). Shoot at high noon with everything in the center of the frame and see what happens. You get the idea. Even if you don't keep at it, get whacky and wonky every now and then to rattle your brain into seeing new possibilities and give your feed a visual jolt.

1 GET UP HIGH

Find some safe footing at the top of a building. Use your camera or phone as a periscope to capture a breathtaking perspective. If you look at an image and you get vertigo or the hair on the back of your neck stands up, you have probably created something impactful.

2 MAKE IT MEMORABLE

An image of four fingers grasping the edge of a ledge would lead a viewer to assume there is a body dangling below that ledge. But the reality could well be someone crouched on a stoop below the "ledge" to create the illusion of risk and drama. The image implies a narrative. Make it funny, risky, exciting, and thrilling.

3 COPY UNTIL IT BECOMES ORIGINAL

Look to other photographers making weird, fun work. Investigate their images with a critical eye—do they shoot super close up with a bright flash? Try it. Do they cast models from Craigslist rather than a modeling agency for real-life grit ? Try that, too. Do they shoot dead flowers rather than just picked blooms? Copy, copy, copy until others' approaches transform into a new way of thinking for you.

4 SHAPE PLAY

When I'm just about being playful and feel like a creative workout, I try to relate shapes to each other. Can a mango look the same as a little thrifted dish which also looks just like a bar of fancy soap? They're all ovals so they all go in the shot. It doesn't matter that they don't relate to one another—because they're all in the same image, viewers will string a story together.

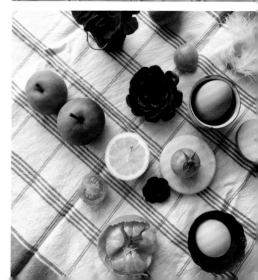

CREATE A STORY

A camera or phone can allow us all to be visual storytellers. An image is quickly digested, and a photo can do so many things—delight, haunt, surprise—so a succesful Instagram feed is one that is filled with memorable shots. You can work up many "sketches" or "drafts" before getting to something masterful; the more you do it, the more articulate your story will become. Pretty soon, the idea in your mind matches what you create. Whatever story you're telling, a mastery of light, a strength or subtlety of color, and bold, graphic composition are always the criteria for creating thought-provoking images

Compose

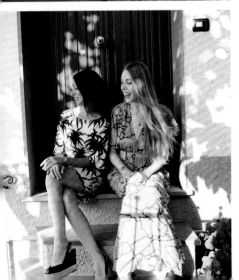

1 MAP OUT A PLAN

Create a shot list or series of sketches exploring different ideas or approaches that you can then use as a map when you're in the moment and it feels overly complicated, or if you run out of ideas. This handy reference will give you creative inspiration and might include a close-up, a profile, an environmental image, a vertical and horizontal alignment, and one crazy idea: bring on the hair rollers and playing cards.

2 RELATIONSHIPS

To create a great story you need to see the subtleties in relationships between people. Relationships can be romantic, or about growth and time. An image of a grandparent and a child is a story loaded with emotion and speaks about the passing of time, and the bonds of family.

3 CONTEXT IS EVERYTHING

To create a nuanced image full of description and meaning, think of where you're situating your subject as much as the subject itself. The space between things can add emotion, visual pause, and give the viewer graphic clues.

4 DIPTYCH OR SERIES

Use a diptych or a series of images to build a narrative. A photo essay in a magazine typically uses ten to fifteen images. There is usually a wide, establishing image; then medium shots; and a few detail shots. Your Instagram feed is a storytelling device with many images comprising a whole. Think of scale, color, theme, and how well the photos relate to each other as you post.

5 LAYER

Layer the subjects to create a deeper story of a place, person, or feeling. A story is stronger and more memorable when an image uses multiple visual indicators. Think of this image in your mind: two friends laughing with each other, sitting in dappled light on the step in front of a green door. Here you have information about the two people (jovial, lighthearted) and their location (outside a home).

BEACH PICNIC

Setting up a picnic on the beach is a cute way to bring together a range of elements, from food and portraiture to travel and textural details. Enlist a couple of friends to be your models—payment can be in the form of a spread of delicious food—and ask a stylish pal to be in charge of props. If you have access to a farmers' market, gather a selection of the best-looking fresh fruit. Add a cutting board, your favorite cheeses, and a bottle of wine and you're set.

GET ORGANIZED

If you can, go to a familiar beach and scope out the best spots and the best time of day to shoot. If it's summer time, plan to shoot when the sun is lower in the sky. Look for an area that isn't too crowded so that you don't have to work too hard to avoid random people in the background.

SET THE SCENE

Lay out your largest elements first—picnic blanket, basket, models—then add your smaller items, such as a cutting board, plates, and fruit. By working this way you can easily see big compositional shapes and use the smaller elements to create a diagonal flow within the composition. Keep major components out of the center of the frame, and remember to leave some negative space.

MOVE AROUND

If you've put a lot of energy into creating a scene, it can be hard to remember to move around when shooting. Work through a mental shot list of various angles and scales. Get in very close on some details—focus on one person with their plate of food, perhaps—and be sure to capture the overall scene with a wide shot.

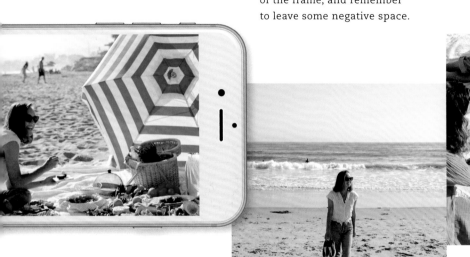

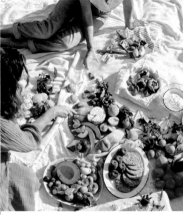

FEAST OF FIVE PASTAS

I love doing a deep dive into a favorite food—for me this is pasta!
I find so much beauty and inspiration in the different shapes, varied
methods of preparation, and styling options. Working with a subject I
love offers limitless potential to create stunning pictures and gorgeous styling.

CHANGE UP STYLES

To showcase a collection
of similar items—in this
case, pasta—try varying the
backgrounds and styles you
shoot them in: try cooked
and uncooked, use different
backgrounds, bowls, and light
sources. Let your imagination
run wild for an hour or two.

ENLIST A FRIEND

It's too much to try and cook five
different pasta dishes in one day
and do a good job photographing
them. If you can get a friend
(even a parent!) who's a great
cook to do this part, you'll be
miles ahead. Split the leftovers
and you will both have a week's
worth of readymade dinners.

PROCESS SHOTS

Remember that ingredients can
be just as interesting, if not more
so, than the finished dish. As
you go along from dish to dish,
consider the beginning, middle,
and end of the meal—the
ingredients, a hero shot of the
pasta, and maybe an empty plate
with a few crumbs nearby.

CREATE A STORY
DESSERTS IN THE CANYON

I have a passion for sweets, and they make some of the very best photography subjects. Typically they are cute (smallish in size), carefully prepared, luscious to behold, and most importantly they make everyone lick their lips and want to eat them. I'd say that's a great starting point for a shoot.

FORM PARTNERSHIPS

Build relationships with your local bakers or pâtissieres. When someone brings an outstanding cake to a party, I compliment the creator and follow up with them to get the recipe. It's very helpful to know people in fields that complement your own— reach out and ask if you can photograph their creations.

BE A LOCATION SCOUT

Use your everyday life as a scouting mission; remember the interesting and special spaces you have come across when you're planning a shoot. Friends of mine have taken over a cool old motel with a rough-and-tumble cabin vibe that works well for a rustic desserts shoot.

THINK LIKE AN ART DIRECTOR

Prepare a shot list of diverse images—whole desserts, slices of pie, a single small pastry, and the person who baked everything. By being aware of the range of images you may want to make, you'll come away with a body of work that's interesting, not just one great picture.

FRIENDS' WEEKEND GETAWAY

Is there anything better than being with a group of friends in a stunning location, wearing fun outfits, and eating fabulous food? I'd be hard pressed to come up with a more perfect, or photogenic weekend. The next time you're organizing an adventure, throw a few extra dresses into your bag and invite your girlfriends for a few days on the road and a chance to play dress up.

GET CRAFTY

Bring the ingredients for activities—this always makes for a good time and helps everyone relax for a few photos. I like decorating cookies and painting. Both help tell a story of a fun girls' weekend and provide cute props.

NO "MODELS," NO PROBLEM

Regular people are gorgeous. The more I go along in photography, the less interested I am in "perfection"; I'm looking for quirks, scars, goofy grins. Confidence in front of the camera is sexy—working with friends creates a relaxed atmosphere and will help you make images that reveal their natural beauty.

WHAT'S IN FRONT OF YOU

The best location or scene may be right in front of you. Don't get caught up in trying to make it to the next activity. Take in the moment and see what's right there. Maybe your hotel room has a fabulous bathtub or fabulous retro blanket; you may find you can create an entire visual story in a single room.

START WIDE

Movies usually start with a predictable pattern of images: overview, medium shot, tight shot, and then detail. The wide shot establishes the scene. When shooting any series of photographs for Instagram—travel, lifestyle, food, or even a portrait—the same pattern can be used. Start with an overview to establish the scene, then move closer in as you continue to shoot. Once you're *in* the scene, turn around or take a breath and ask yourself, "What am I missing?"

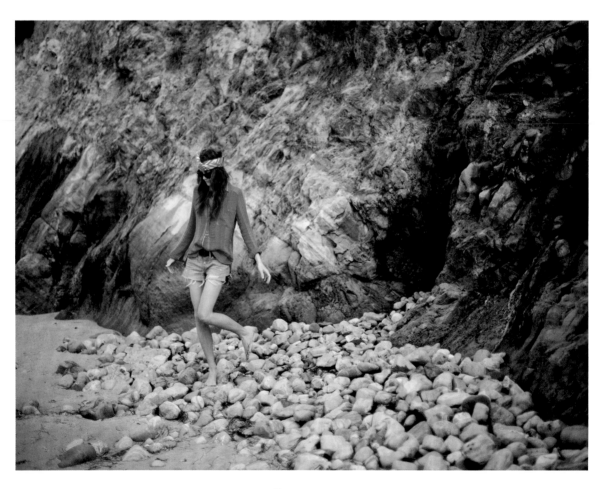

Start with an overview to establish the scene, then move closer in.

1 FILM SCHOOL

Study wide shots from films and think about them when creating your own composition. From contemporary to classic, note how the first thing you see sets the mood of the entire movie. Some greats are the 1963 version of *Cleopatra*, which begins with a carefully constructed set of ancient Egypt and a throng of extras in red tunics; the first scene in *Indiana Jones*, which is all about a boulder coming toward our lead character; and *Lord of the Rings*, which sets the scene with a series of epic landscapes. None of these are by accident.

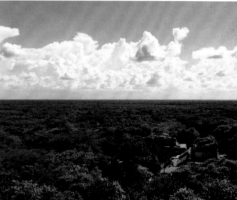

2 COMPOSITIONAL RULES

When setting the scene for your visual narrative, keep the compositional rules in mind. Think of the foreground (paved square), middle ground (terraced buildings), and background (blue sky)—do you have something in all three planes? Can you walk through the scene visually?

3 CAMERA LEVEL

Hold the camera or phone at waist level rather than at eye level. By shooting from mid-body height, you will capture sky, horizon, and ground in equal proportion. Shooting from a lower position makes it easier to represent horizontal and vertical lines as straight, too, and will give your shots a more purposeful composition, avoiding the amateur look of eye-level shots.

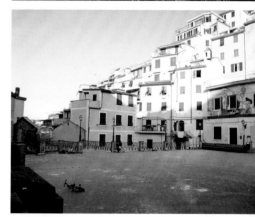

4 WATCH YOUR EXPOSURE

Aim to show the scene in its best light. Position yourself high above the scene and wait for sunset, twilight, or dawn. Shoot at a slightly underexposed level to capture vivid colors; you can always brighten the darks by adjusting the "shadows" setting in Instagram editor.

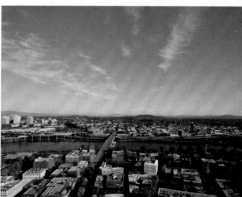

MESSY

Working in an all-over-the-place, messy style is the most fun compositional approach. The more irreverent and free from expectations you feel and act, the better. Keep a light rein on all this wild abandon; there's a fine line between disheveled, lived in, and funky, and total, senseless chaos, so be mindful and ride the edge of the two looks.

1 REMEMBER NEGATIVE SPACE
A messy composition still needs negative space to work. Begin by loading up the composition—lots of ingredients for a food scene, a collection of beachcombing treasures, or an array of bits and bobs for a still life—and remove piece by piece to create a little negative space.

2 GIVE PHOTOS A LIFE FORCE
Even a touch of messiness brings a life force to an image by signifying human interaction with the setting. Resist the temptation to clean everything away after a party and try shooting the scene with evidence of a good time in place—a few crumbs, lipstick stains on the china, wine spilled on a white cloth. You may find a far more interesting image than you did at the start of the party.

3 DROP IT
When garnishing food or creating a messy scene, scattering from above is a beautiful way to replicate the random patterns found in nature. Instead of systematically placing individual leaves with tweezers, sprinkle them from above—where they fall is where they should be.

MINIMAL

Creating a subdued, sparse composition is tough—but when you nail it, the balance of light, line, and shape sings. A pared-back composition can say more than a frantic or busy arrangement. The next time you're creating a still life, a portrait, or even photographing a room, consider removing elements to bring the essence of your subject to the fore.

① MASTERS OF COOL MINIMALISM

Tina Modotti's still lifes and Robert Mapplethorpe's intense studies of flowers are the epitome of a cool perfection without artifice or fluff. Images of a single item ask more questions than they answer, and that's what makes them so haunting.

② SIMPLE IS NOT BORING

Once you've chosen your subject, try simplifying the scene. This could mean shifting your shooting position to omit trees from the perimeter of an image of the sky, or filling the foreground with a jumble of shells and pebbles breaking across the horizon.

③ INCLUDE NEGATIVE SPACE

Minimalist photography is as much about atmosphere as subject. If you want to incorporate an object, try including a small figure and a lot of sky. Negative space is your main tool for directing the eye to the subject, or lack thereof.

④ CROP

Centering your subject, then cropping most of it out of the frame creates intrigue and an element of surprise, making an image that viewers will linger over. This is particularly effective when photographing people.

CREATE DEPTH

Including layers—something close to camera, in the midline of sight, and far behind the subject—creates depth in a photo. A sense of three-dimensionality in an image creates dynamism and interest in the picture plane. A layered image is not sterile or flat; it more closely resembles real life and the way we move through spaces. It's an instant boon to your work to think in 3-D rather than 2-D.

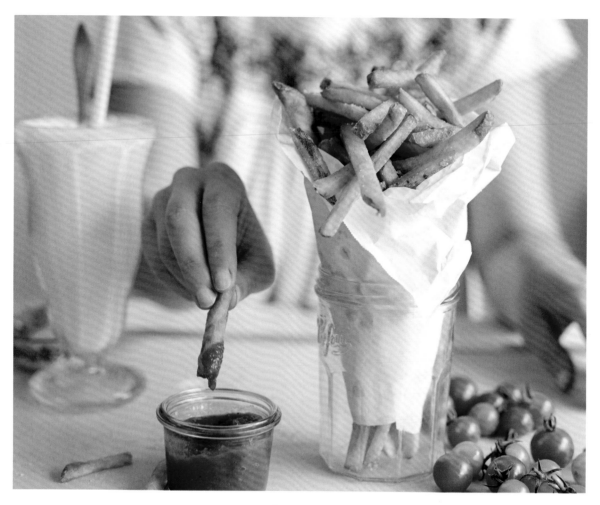

1 CREATE OBSTRUCTIONS

Look for objects you can use to protrude into the edge of
the frame and obscure the composition of a simple shot.
A cluster of leaves held close to the lens can create the effect
of shooting through a tree; a piece of glass can add a subtle
blur in a corner. Breaking into the edge of the frame will add
a sense of space. Placing leaves very close to the lens makes
them appear soft and blurry, and introduces a soft field of
color that works to direct the eye toward an architectural
detail, such as this spiral staircase.

2 SELECTIVE FOCUS

Focusing on one point and slightly blurring the rest of an
image will create depth of field. Use depth of field to help
isolate what you're looking at, and add a subtly emotive
feeling to an image. On a phone use "macro" mode; for a
camera stop all the way down to your lowest aperture.
An isolated focal point—a person with gorgeous hair pulled
from the background, or a fun cocktail in someone's hand—
forces a viewer to pay attention to what occupies that point.

3 FAMILY PORTRAIT

Here's a little exercise . . . Construct a family portrait with
a teenage girl in sharp focus, sitting looking at the camera.
To the side, slightly behind the girl and softly out of focus,
have a woman looking at the girl. In the background have
a man out of focus but implying a masculine figure. You
have just created a story about a family by using different
depths of field.

4 PORTRAIT MODE

Using portrait mode on your phone will isolate your subject
and slightly blur the background. This is a quick way to add
intensity and the feeling of space to an image. Remember,
your subject doesn't necessarily have to be a person—you
may choose to focus on swaying branches, heavy with
elongated leaves.

SMALL MOMENTS

You can create intimacy with a small, specific detail—light catching on a cluster of wildflowers, the way a feather intermingles with a leaf, a pool of chocolate oozing from a perfectly baked chocolate chip cookie. These minutiae prompt the viewer to build a story in their mind. So get in tight, closer than you think you should be—the more zoomed in and less specific you are, the more space you give the viewer's imagination.

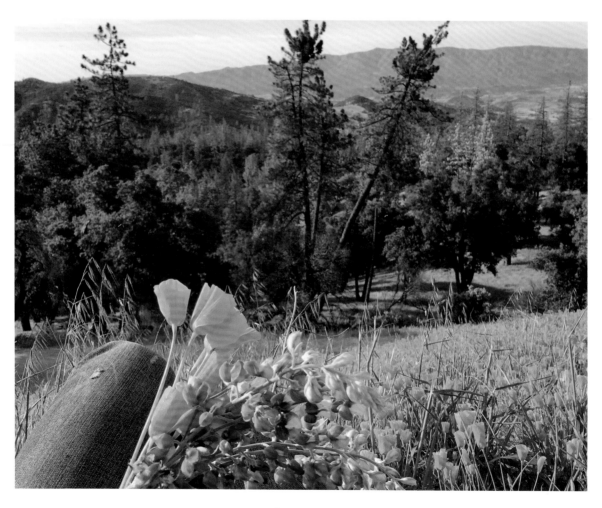

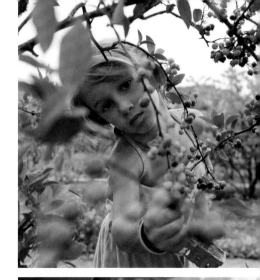

1 DETAILS MAKE THE STORY

Accessories or details on an outfit can help embellish a scene.
A hand-stitched seam, a bright red bow, layered costume
jewelry, or a worn-in, sun-bleached hat help the viewer
construct a narrative around your subject.

2 LOOK FOR HANDS AND GESTURES

We speak volumes with body language. A great photographer
can capture nuanced expressions to reveal a person's quirks
or the bond that exists between two people. Pursed lips and
a concentrated gaze give the viewer a window into who the
subject is. When you have faces in an image, they belong to
specific people and not the viewer. When you have interlocked
body parts or nervous feet, your images convey the singularity
of the subject(s) you're portraying.

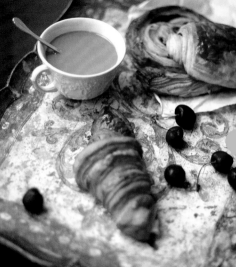

3 SLIVER OF LIGHT

Just a whisper of light within a mostly dark picture plane can
become a striking story; a poem rather than a billboard.

4 MACRO SETTING

The macro button allows you to get close up and retain detail.
The focal point (a cup of tea) will be sharp, while the image's
perimeter or background (pastries and cherries) may fall out of
focus. The effect of this focal play is to create a sense of depth
in your image.

5 GO SLOW

Finding details and small moments is about taking your time.
I try to arrive early when I have an appointment and spend
time observing my surroundings. This "spare time" allows me
to capture the small moments of beauty—perhaps a delivery
of flowers sitting on the pavement outside the florist's—that
I would have missed if I was rushing to arrive on time.

@littleupsidedowncake

Sanda Vuckovic Pagaimo
littleupsidedowncake.com

After a year working in IT, Sanda realized that it was not a road she wanted to continue on; something else was commanding her attention—organic food and food photography. She now works from home and fully enjoys what she does. Every day.

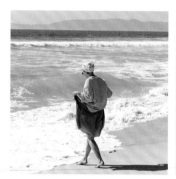

time

Every season, every time of day has its own beauty. It can be a challenge to transmit that beauty in an image if the light is too strong, the grass too green, or the background too busy.

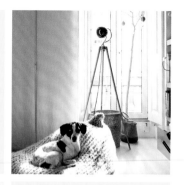

light

I use direct light when I want to create a very strong message, and diffused light when I want a more romantic, subtle mood.

composition

I usually think in advance about colors and props, but composition and mood are mainly decided on the fly. I think when composing I put a bit of myself, my mood, my life, memories, and personal story into it.

adjustment

I usually use the VSCO app on my phone images and adjust for brightness. I also use Afterlight for framing images.

satisfaction

Instagram is my favorite social network platform. I have met so many great people through my work on the app—some in person.

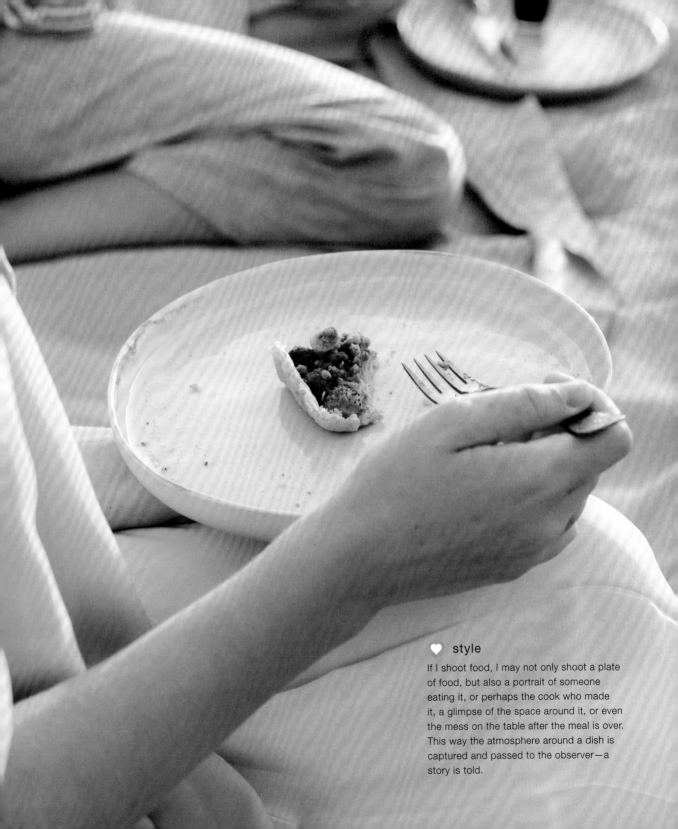

♥ style

If I shoot food, I may not only shoot a plate of food, but also a portrait of someone eating it, or perhaps the cook who made it, a glimpse of the space around it, or even the mess on the table after the meal is over. This way the atmosphere around a dish is captured and passed to the observer—a story is told.

SEEING THE WHOLE

Everyone starts with the subject. Try a different technique and start with the environment. Shoot the negative space: the spaces between things. The figure-to-ground relationship is critical in this approach. Practice shooting this way and you'll never see the "thing" you're shooting without also seeing the world it lives in. The setting can be a complicated, junk-filled bedroom, or a simple wall of solid color. Whatever it is, make sure you're aware of how the colors, textures, and shapes are interacting with the subject.

1 HUMBLE PIE

A good portrait does not always scream, "Look at my face." It can be subtle and nuanced, with the subject positioned in a corner of the frame and peering out from a dark interior. This setup can convey a sense that the subject has secrets they are not revealing. You can amplify this atmosphere by creating a lot of space around the subject and including only part of the figure in the frame.

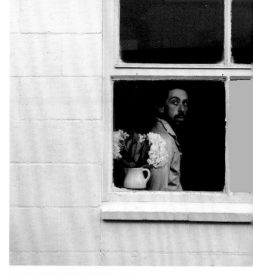

2 BACKGROUND

When shooting food, pay attention to the table or cloth on which the plates are set. If the food is complicated and full of garnishes, balance the whole by using a simple linen tablecloth, or have fun and play with pattern by using a wild, colorful cloth as a contrast to a single bowl of white rice.

3 IN THEIR ELEMENT

Compose an inclusive setting by placing a subject in their world and asking them to do their thing. A chef? Photograph them in their kitchen preparing a dish. A craftsperson? Shoot them in their shop making something they are proud of. By placing the subject in their world you see the way in which they interact with it and capture context.

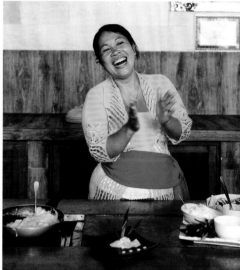

4 CLUES AND CONTEXT

When shooting a building, landscape, or landmark, the sky and ground areas are as important as the subject. Can you exploit clouds, rain, or rays of sunshine to add a certain mood to the overall scene? Perhaps flowers are growing at the base of a building where concrete meets metal? Or are the feet of busy commuters swarming all around the subject? Being sensitive to the details surrounding a subject may lead to a more intriguing image.

OPPOSITES POP

Experimenting with opposites is an effective approach when you want
to get out of a creative rut. This method is like wearing pajamas to school
or eating breakfast for dinner. Doing or thinking exactly the reverse of what
you're "supposed" to do is inspiring, energizing, and downright delightful.

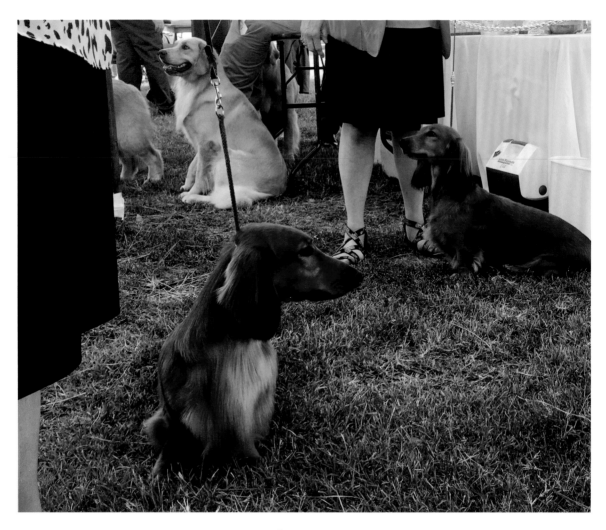

1 GET UNCOMFORTABLE

Do the reverse of whatever you're comfortable with. Your "look" may be minimalist, reserved compositions of very few items; if so, go Rococo with a riot of objects in the frame. If you are always shooting food or still lifes, grab some friends and do a portrait session. Your models will all appreciate a new headshot and you will have flexed new creative muscles.

2 MAKE MISTAKES

Moving away from what comes easily to you is not always fun. It's hard to grow creatively, but pushing into unknown territory is how you do it. When you create an image, look at it to figure out how to make it better, but also try to exaggerate the "mistake" or weakness. I know it sounds crazy, but push in both directions. You may surprise yourself!

3 ASK QUESTIONS

Never look at your work and say to yourself, "What do I have?" Always ask, "What have I not tried?" and dive in again. By training yourself to go deeper and be more thorough with your process of investigation, you'll learn and advance toward creating a beautiful and inspiring Instagram feed.

4 START IN A DIFFERENT WAY

If your habit is to set a still life using only your favorite fruits, try working with all of the "ugly" fruits you find at the market, or "deconstruct" the fruits you typically use by peeling and cutting them and see how this impacts your approach and the image you create. Starting out by throwing your creative eye off balance will almost always lead you to somewhere different, and perhaps, to produce something extraordinary.

> Doing or thinking exactly
> the reverse of what you're
> "supposed" to do is inspiring.

FLORAL

The rich and evocative language of flowers has been used to incite passions and describe feelings for centuries. In some cultures the yellow rose signifies friendship and joy. A red rose expresses love. Fill your Instagram feed with images that tap into the aesthetic qualities, color, and symbolism of flowers.

1 COLOR

First and foremost, flowers can add a bright pop of color to a composition. White in a floral landscape brings a mellow mood for the eye to rest upon; a bouquet of white lilies in a plain room adds a subtle spirit and beauty; and a loose arrangement of blooms will light up the corner of a kitchen scene.

2 LIFE CYCLE

Fresh, dried, in the process of dying—there is beauty in every stage of the life cycle of flowers. Old Masters included decaying flowers in their still life paintings. Follow their lead and bring emotion to your image by including objects that are past their "prime."

3 SCATTER

I love flowers in their glorious entirety of form, but I sometimes prefer the compositional element created by breaking them down into petals and leaves. Scattering these smaller shapes across a picture will add movement, texture, and small points of interest that carry the eye around the image—not to mention a hint of romance!

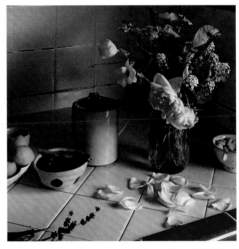

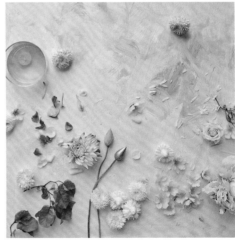

PLAYFUL

In order to make subjects respond and engage in the process and to create
images with a relaxed sensibility, it's imperative that you radiate lightness.
Having a playful, curious attitude while you're working will make the
process of creating playful, energetic images more intuitive.

① PLAY WITH COLOR

Pile all the yellow objects you have onto a white
surface; shoot and then reverse the setup and shoot
white on yellow. Arrange a collection of clashing
colors on a pedestal that almost matches the backdrop
to generate an uncomfortable, silly, vibrant feeling.
Color can make you laugh if you get the vibe right;
keep playing until something tickles your funny bone!

② ARRANGEMENT

Set a timer, and using the same ten objects, come
up with as many arrangements as you can in ten
minutes. This exercise is like freehand writing or
sketching before you paint; it opens you up to
possibilities and warms up the creative muscles.

③ DISCOVER

Take five minutes everyday to collect a handful of
objects that represent the place you are in. Situate
them on any available surface—I have used baking
trays—and make a little portrait of the collection.
This creative game will heighten awareness of your
surroundings and acts as a great lesson in how to
create visual interest using whatever is around.

RESIST UNIFORMITY

Experimenting with chaos and rejecting order is a fun compositional device. When styling a scene, I'm always thinking about the message I'm trying to convey, and the arrangement that will best communicate that message. Natural, unfussy, and perhaps somewhat loose styling says something very different to a neatly arranged grid with minimal props. Decide what you want to "say" and get busy!

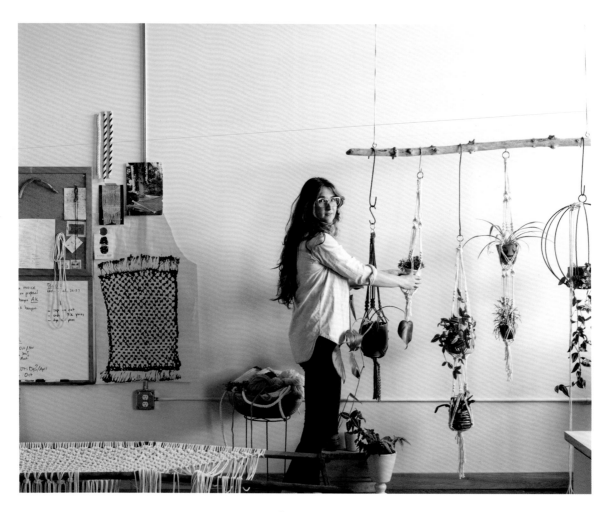

Abundance gives
you room to play.

1 QUANTITY MEANS QUALITY

Start with more than what you think you need: more vases, more jugs, more pots, more candles, more people. It's easier to take away a surplus than to hustle up more of whatever you need at the last minute. Abundance gives you room to play and experiment as you build a scene up and then edit out elements to get the composition that works.

2 ONE GOOD, MANY BETTER

One kitsch plastic clock on a wall can look fun, but an array of six clocks each showing a different time is a party. This strength-in-numbers approach works in many situations; look for retail displays with the regularity of items arranged according to a particular set of criteria—lots of narrow vertical shapes, for example—or at a farmers' market, where fruit is lined up in lovely little baskets. More is better.

3 SEEK MASTERS OF ORGANIZATION

Once you start looking at the way information and items are displayed, you'll see tidy grids of cute objects everywhere. You can find great work on this theme with the hashtag #ThingsOrganizedNeatly.

4 SEEK MASTERS OF CHAOS

There is a fine line between a photo of a pile of junk and an artfully crafted disarray of beautiful materials. Pile a collection of lush fruit with strongly contrasting colors on serving dishes, and let the shapes flow and spill over the edges. Think of nature when composing in this way—leaves fallen from a tree and scattered on the ground in a beautiful random pattern— and try to emulate that perfect sense of chaos by leaving elements in your composition where they fall.

CAPTURE EMOTION

Photographing emotional scenes may be the hardest thing to do. It can make you and your subject uncomfortable. In situations of great emotion you want to put down the instrument and be a human being. You have to *be there* for these moments, establish who you are, and have trust built rather than walk in the door and press the "capture" or shutter button. It is critical in these settings to show those present that you respect them—and possibly love them—and that taking photographs does not diminish your feelings. After this is clear, go in and photograph as close as you can. The tears of joy and the tears of sorrow, that's where the good stuff is.

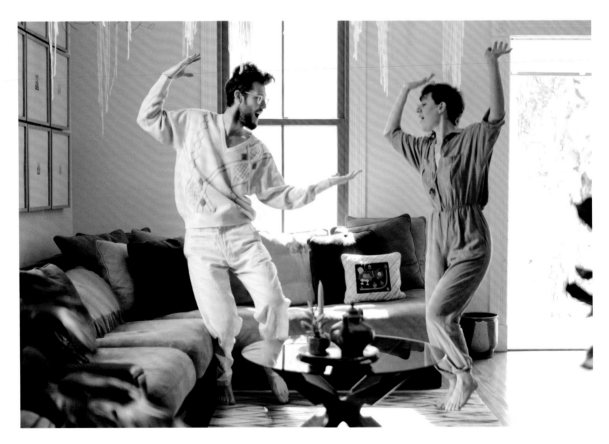

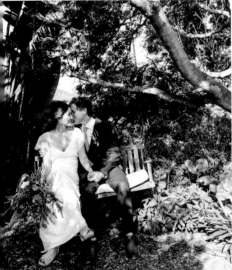

1. RITUAL AND CEREMONY

Social, religious, and political ceremonies are where passions collide. These events can be hectic and fast moving, so wear a comfortable outfit and be ready to move around the scene. Exercise your skills in getting close to people and shooting by starting with a little rapport building. Ask them nicely about their reason for being there, then fire away.

2. PRACTICE ON YOUR FRIENDS

Become the "photographer" at every wedding, birth, or big event in the lives of friends. It may be that they have hired someone else "officially," but the people you know and love so intimately make great guinea pigs and these, typically, relaxed situations are an opportunity to try out new things that can later be applied in images you create for your feed. Ask friends to hug, ask them to laugh—invariably it turns into real laughing and then it's just a hoot.

3. TOUCH

There's nothing more awkward than friends or loved ones posing for a camera and not interacting with each other. You can direct them a bit, never touching them, but motioning for them to put a hand on a shoulder, whisper a secret, gesture at each other. This will help warm them up and reveal the love shared between intimates.

4. THINK ABOUT EQUIPMENT

A high-end camera makes you more formidable; a phone makes you more like an average person. Don't think file size or pixel count; think of what will work best for the situation. If you are at a formal organized event it may be that the authority of a camera is the better choice, while an intimate scene in an ocean setting at dusk is best captured through the familiarity and casualness of a camera phone. Use what most helps you capture the idea you're going for.

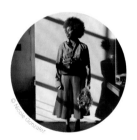

#fridayfollow

@LaTonyaYvette

LaTonya Yvette Staubs
latonyayvette.com
blog.latonyayvette.com

LaTonya Yvette Staubs is well known on the internet as simply LaTonya Yvette. She is a stylist, activist, writer, and mother of two. Her blog, LaTonya Yvette, has captured, with candor and grace, notes on motherhood, style, and all of life's ebbs and flows.

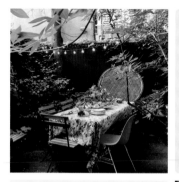

♥ style

I live and work in the same context. I use "intersection" a lot when describing my work, and everything I do in passion and work is truly a representation of a woman standing at an intersection.

♥ adjustments

I recently started to skip the filters, and it's been the biggest eye opener in how I view imagery. I take down highlights in the photos section on my phone while it's raw and play around with what that does for the colors.

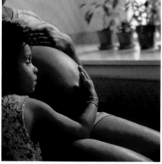

♥ tips

Clean your lens before snapping. Get down to their level. Let the camera be a prop, but not the lens in which you view the scene.

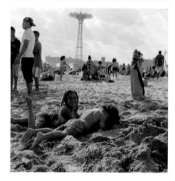

♥ color

I see the world through color. I am drawn to it in my clothes, in writing descriptions of scenes, in noticing things about my children, and my social media feeds. It is who I am.

♥ satisfaction

Having people be moved. Truly. I love the way Instagram has become this thread with which we are all connected. That feels like good work to me. When I'm eighty-something and asked "Instagram—what? What did you do?" Well, I moved people.

Compose
154

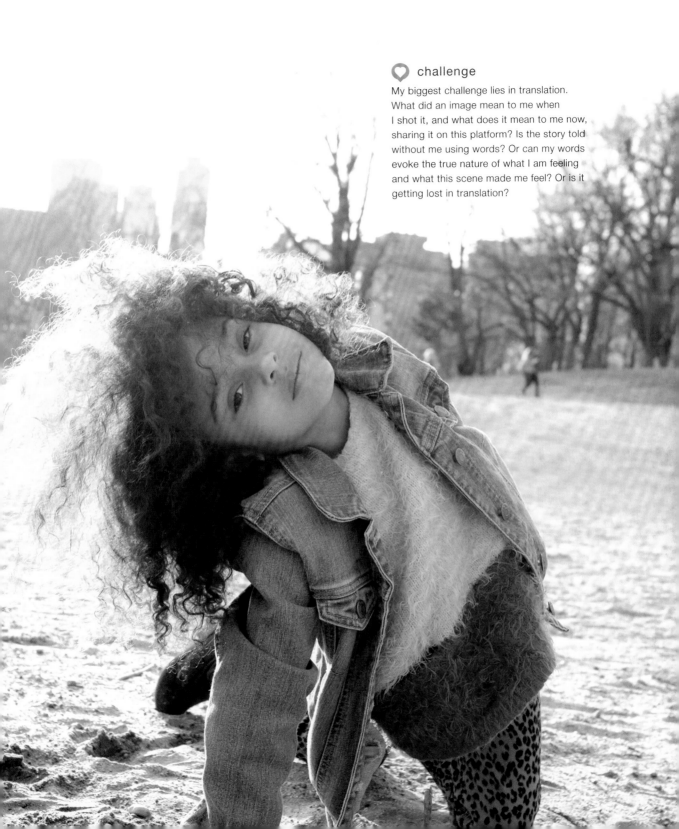

challenge

My biggest challenge lies in translation. What did an image mean to me when I shot it, and what does it mean to me now, sharing it on this platform? Is the story told without me using words? Or can my words evoke the true nature of what I am feeling and what this scene made me feel? Or is it getting lost in translation?

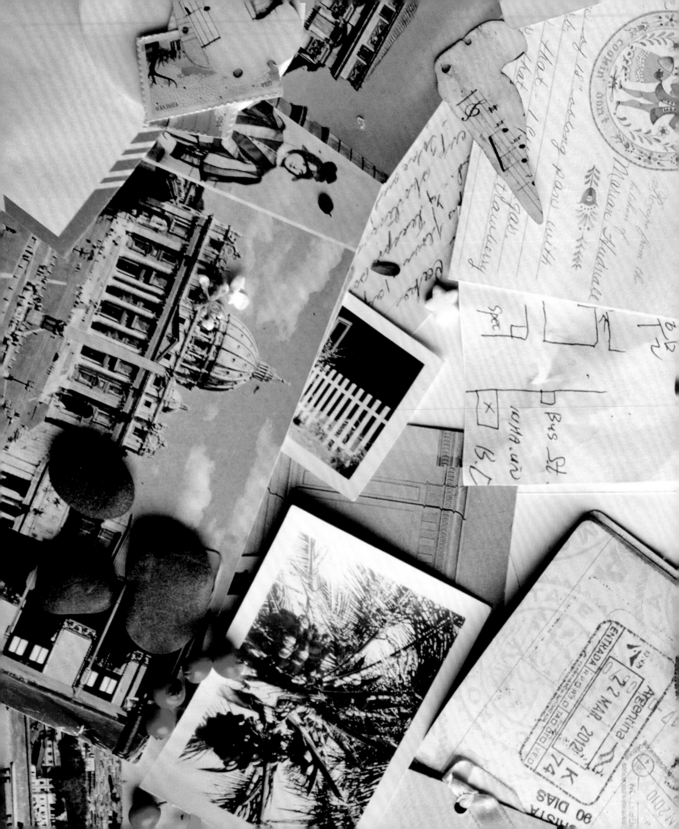

8

PLACES AND SPACES

MOMENTS IN TIME

Before I book a trip, I research major festivals at my destination. Capturing the exuberance of a unique local experience adds authenticity and energy to my images and dazzle to my life. There's nothing like getting caught up in a throng of revelers—the dancing, food, colors, and music are all so grand—I'm dancing in my chair at the thought.

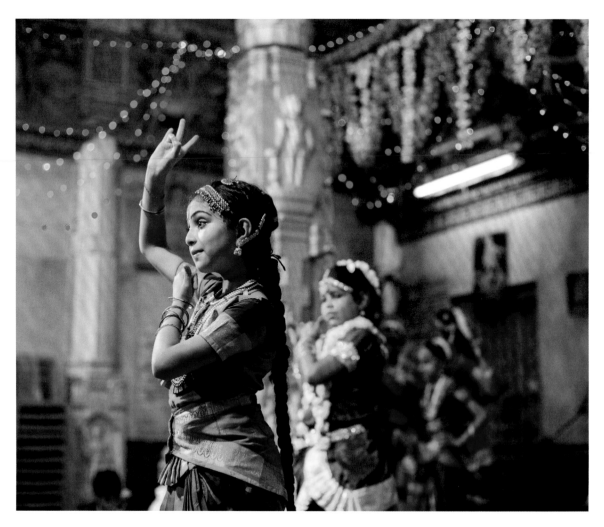

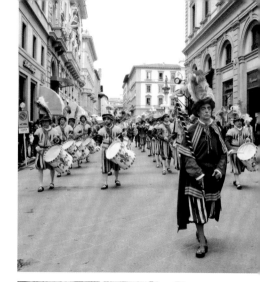

1 THINK LOCAL PRESS

Local print media—*Time Out* magazine, a local newspaper, or even flyers posted around an area—are all excellent resources for discovering street fairs, festivals, and markets. So even if you can't plan your trip around some annual event, there is probably something shaking while you're there—you just have to find it. I once happened to be in Florence, Italy, for Easter and witnessed the most surreal Renaissance-costumed procession: an ox with head-to-toe floral decorations, colorful smoke, a bejeweled carriage, and the release of a dove to signal spring. It was incredible!

2 STAKE OUT A SPOT

Go out early, get a coffee, mill around, watch the light, and imagine what may transpire. Wear comfortable shoes, bring some playing cards, and settle in for a front-row view of your unfamiliar surrounds—the attitude of a patient, curious observer will get you much better photos than if you try to shoot your way through the back of a million heads.

3 PLAN AND BE PATIENT

Public events can be three-, four-hour, or sometimes all-day affairs. After taking the time to assess the place, the space, and the people, let events unfold. Don't be in a rush to "get" your shots; there is an energy and momentum to these situations. Commit to being there and being ready to capture the magic you discover. I couldn't have planned to get a shot of rally car drivers enjoying an ice cream.

4 STAY LATE

The aftermath may offer just as many opportunities for great shots as the main event. When people are clearing out, confetti is strewn all over the street, costumes and decorations are piled in a corner, and the performers are stopping for a cappuccino in their sparkling outfits; you see the juxtaposition of glitz and grime and have the opportunity to capture some really interesting images.

COLORS OF THE MARKET

A lively market in a foreign country (or the farmers' market down the street) can be one of the most productive locations for creating dynamic imagery. The colors, layers of texture, and charismatic vendors fascinate photographers and viewers alike. Carve out a couple of hours to celebrate the intersection of commerce and humanity, an age-old combination!

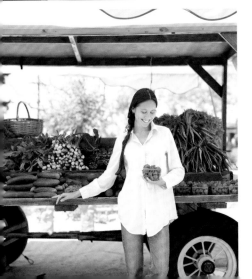

1 | GET BRAVE

It's no good being a disinterested observer when photographing vendors and market goers—it is critical in this situation that you adopt a very confident, extroverted persona and ask people questions. Fake it if you have to. Vendors will warm to you as you ask about their products: then you can casually ask if you might photograph them. Compliment their smile, stand, or earrings—whatever it takes. People usually say yes.

2 | SEEK PATTERN AND REPETITION

A market stand is often a vendor's main source of income and they take great care to display their goods in an enticing and organized manner—rows of strawberries, mounds of blood oranges, and baskets of flowers all create visually arresting and graphic images.

3 | WHITE TENTS

Ever wonder why all your pictures from a farmers' market look so pretty? The white shades under which the sweetcorn is sitting create a diffused light, perfect for enticing produce shots—take advantage of this ready-made filter and shoot an array of pretty fruits, vegetables, and flowers.

4 | SHOPPING WHILE SHOOTING

Shooting while carrying a lot of stuff in your hands is very difficult, so go with a plan. Better yet, shop and shoot simultaneously, but get a friend to carry everything so you are free to observe, capture a moment, and share a laugh.

5 | VARY IT UP

Shoot detail, medium, and wide shots. The story you are chasing may be better captured in a portrait of someone surrounded by produce than a busy wide shot of market goers. Often you can't tell where the story is strongest until you review your images. So cover the market with the zest of a seasoned photojournalist and give yourself options.

LOOK BEHIND THE CURTAIN

Go behind the scenes—into the workshops, kitchens, and laboratories of the world.
There are always people dedicated to a craft, working their butts off, who would love
to chat with a curious photographer. It's easier than you think. It's a matter of
mustering up a little courage and asking to speak with the creator. This question can
give you access to a whole new world. The payoff is vast, and allows you to form
connections and capture backstage images of a place and its people.

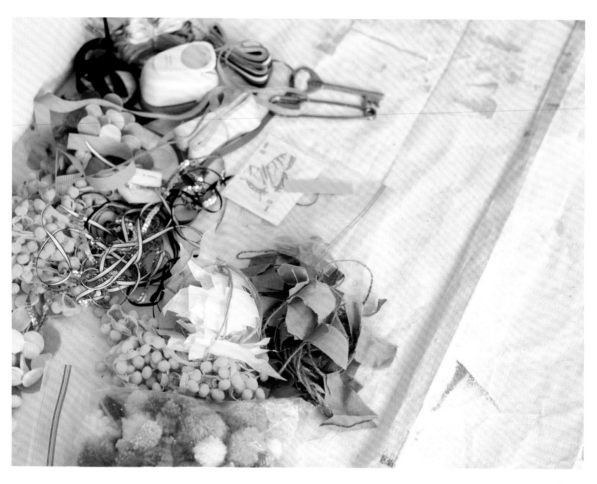

There are always people dedicated
to a craft, working their butts off,
who would love to chat with
a curious photographer.

① INVESTIGATE SCHOOLS AND ATELIERS

I love to go to cities with Carnival or Mardi Gras, not only
New Orleans, but Rio and Trinidad and Tobago. I came across
some float workshops in India and met some incredibly
talented papier-mâché artists. Many craftspeople and artisans
work in isolation. All you have to do is express an interest,
begin a conversation, and let the images come to you.

② MEET THE CHEF

If you have an amazing meal in a restaurant, ask to say "Hi"
to the chef. You already have a great conversation starter: the
food you've just eaten. Michelin-star restaurant or roadside
diner, you never know what you'll find behind the scenes.
Even if you only get to spend five minutes in this hidden
world, photographing food, culture, and the spaces where
these topics intersect is always wonderful.

③ SEEK HIGH AND LOW

Maintaining a single behind-the-scenes perspective while
traveling can be exhausting. Keep your creative and physical
energy up by mixing fancy and gritty scenes. Look for workers'
canteens with plastic tablecloths and opulent dining rooms
with velvet seats. The experiences you have, and images you
make, will be completely different, but you may also be
surprised to discover similarities.

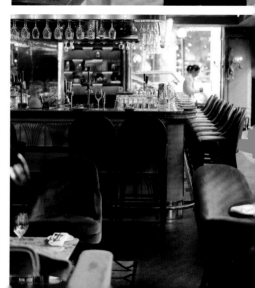

@JonnyMagazine

Jonny Kennedy
jonnymagazine.com

Jonny Kennedy is a Londoner working in book publishing. Since picking up a camera just two years ago, he has explored his creativity and photography skills to the full, and is always on the hunt for something new, exciting, and—most importantly—fun.

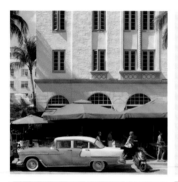

challenge

London is a busy city, so the biggest challenge I face has to be the number of people. They can get in the way of a great shot but it's okay, I'm fairly patient.

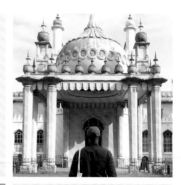

color

I'm from London, which can be a pretty gray city, so I guess subconsciously I'm looking for color—something that stands out and is just plain fun.

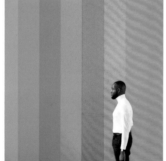

inspiration

I'm definitely drawn to faces and people within their own environment; not so much a sit-down portrait, but everyday things—taking the bus to work, a market place, a cyclist on his way home.

adjustments

If I do use filters it's subtly. I may brighten a little—it goes with my colorful themes. I want the black to be a real black, not faded, to give an image more depth and impact.

favorite

I like the soft light of autumn and the dramatic shift from the bright sun and green parks of summer to the misty mornings and leaves on the ground.

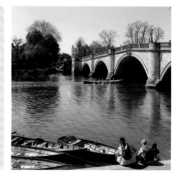

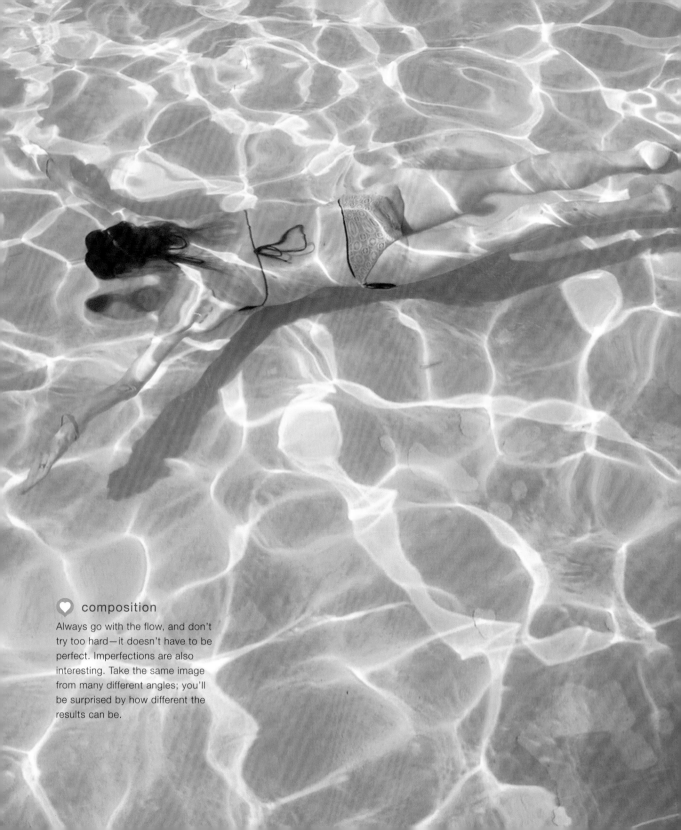

❤️ composition

Always go with the flow, and don't try too hard—it doesn't have to be perfect. Imperfections are also interesting. Take the same image from many different angles; you'll be surprised by how different the results can be.

BE AN ICONOCLAST

We know what the Eiffel Tower looks like—so, too, the Tower of Pisa and the Taj Mahal. These landmarks are etched into our minds, but it is the job of a photographer to see and document ubiquitous subjects in a fresh and arresting way and displace the norm. It can be tricky to shoot iconic locations, but armed with a few tips and a new attitude you'll be getting weird in no time.

1 EMBRACE OR AVOID CROWDS

When visiting a monument, go very early before anyone gets there—as I did when visiting the sculptures at Pietrasanta— or celebrate the fact that there are throngs of people with you. Both situations hold beauty. A setting devoid of people can amplify the stoicism of a monument, while a chaotic sea of humanity can reinforce the significance of a place.

2 ASK AND YOU SHALL RECEIVE

If you strike up a conversation with a curator, official, or docent at a museum or monument, it just may open doors. Sometimes getting access to a new angle is simply a matter of making a connection with the person who has inside knowledge, and a key.

3 SOUVENIR SPECIAL

Don't ignore the gift shop or souvenir vendors. A tray of miniature Eiffel Towers or row of gondolier's hats may have more charm than the real deal.

4 FORGET ZOOM

Never shoot a site with a long lens or extreme zoom. Your image will be flat and boring. Look for something intriguing in front of the monument—a couple embracing, oblivious to the importance of the site behind them, or a kid eating a popsicle and looking bored even though he's at a "wonder of the world."

5 GET ON THE WATER

When all else fails, take a river cruise or ocean ferry. Stack the cards in your favor and take a twilight cruise. Look for reflections in the water, or in the glass of the boat. Can you capture the monument and people viewing it in the same frame? An image of the Eiffel Tower and a couple reflected in the window of a boat traveling on the Seine may hold more romance than the iron monument alone.

SHOOTING NATURE

Showing the natural aspects of a place defines a location. Picture Los Angeles with no images of the sea, Kyoto without cherry blossom, the Sydney Opera House without the harbor—impossible, right? If you love being outside, you've probably seen a landscape photo that has made you gasp. Photographing nature is a chance to disconnect from the day-to-day grind, meditate, seek a stunning composition, and breathe fresh air. You may have to be patient and wait for the light to be perfect or a bird to fly through your scene, but the anticipation is half the fun. Relax and enjoy.

1 LEAD THE EYE
When dealing with a vast expanse of outdoor space, you have to be ruthless in your composition and edit down the overall view. Variations in shape and line will draw the viewer's eye over the picture plane. A long road with a tree in the distance could be framed with a green crop in the foreground (small shapes), the stretch of road (line), and fluffy clouds in the background (large shapes) to direct the viewer's gaze. Together these elements make for an intriguing photograph.

2 ADD PEOPLE TO SHOW SCALE
To show how big and wonderful a place is, add a human to the scene. This effect is amplified if the person is a child.

3 WILDFLOWERS
Know when the wildflowers are in bloom, and if you can, plan your travels to coincide with this explosion of earthly color.

4 CREATE AN ALTERNATIVE PORTRAIT
Use collections from nature to create a "portrait" of a place. Gather small elements—rocks, shells, seaweed, stones, sticks—and assemble them in a grid of uniform rows. This subtle narrative about a place is a great creative exercise and it is always fun to forage around for little treasures.

5 FOG, RAIN, SNOW
The great outdoors are not always sunny, and nature is not always inviting, but don't hesitate to shoot in the rain or snow. You have less competition and often the light is much softer. The morning sun filtered through fog creates a beautiful glow across a landscape. Just remember to dress appropriately.

Anticipation is half the fun.
Relax and enjoy.

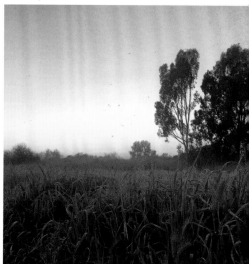

ASSIGNMENT
ALL CHANGE

The journey is the destination is an old maxim but it's the absolute truth. Shooting the "getting there"—the bus stations, train rides, motorbikes, taxis, tuk tuks, ferries, rice boats, tiny airports, and bicycles—can showcase an integral element of the day-to-day functioning of a culture. The trick to creating interesting images is in the way you perceive this often-mundane event and transform it into an intriguing photo assignment.

GO LOCAL

Using local transport is a sure way to engage with the world you have entered. You have to figure out how to buy a ticket, plan your route, and spend time (perhaps hours) with a large number of people you don't know—sometimes all in a language you don't speak. As a guest you can be curious and ask questions of your traveling neighbors. You can photograph them, too—just politely smile, perhaps laugh a little, and you may be on your way to having a life-altering conversation with a new friend.

PRACTICE

It takes persistence and repeated failure to succeed in photographing someone right next to you. True, it is not easy . . . but you want that intimacy. It makes a photo great.

RIDE THE TRAIN

A train journey can feel like being in a bustling mobile city filled with people, noise, games, and food. Don't miss a moment of this fleeting, transitory community. Take pictures, bring food to share, have people take pictures of you, then reciprocate. Show them the results on your screen; it's a great way to start a conversation.

TRANSPORTATION OF GOODS

Step out of the passenger car and try shooting carts, trucks, or motorbikes loaded with the stuff of everyday life— livestock, produce, flowers, building materials. The sky is the limit. You just never know when someone on a scooter will zoom by with a baby on their knee and full-size fridge strapped to the seat.

A LOCAL PERSPECTIVE

Travel isn't only about where you go; it's also about how you see the world. Photography offers a golden ticket to deep exploration, to peel back layers and develop a real sense of a culture. If you have a camera or phone and are curious, it is possible to learn something new anywhere you go. Be bold and go forth with the assumption that your thoughts and questions are relevant and your images meaningful. This attitude may feel unnatural at first, but with practice and the successful images that result from this tactic, you'll find it easier and more fun. Don't only take this approach when traveling—it can also be used in your hometown to create images filled with authenticity.

If you have a camera or phone and are curious, it is possible to learn something new anywhere you go.

1 ASSIMILATE

Get a haircut; buy a coffee from a locals' café; take the commuter bus crammed with people (and sometimes chickens); go to a communal bath or spa for an alarmingly vigorous massage with oils you can't identify. Photographs of these scenes will be quirky and distinctive.

2 LEARN A GAME

In Asia, dominos and checkers rule; in New York City, people play chess on permanent boards in Washington Square Park; cards are universal. If you know a game or two, playing with locals can be a great icebreaker and lead to some memorable shots of your opponents, their friends, and the scene.

3 TAKE DRIVING LESSONS

This may seem like offbeat advice, but since taking tuk tuk driving lessons in Southern India at age 16, I've asked for them in nearly every country I've visited—the teachers are always baffled, but accommodating. The hilarity that follows will make your sides split and guarantees wonderful, funny pictures.

4 GO ON A FOOD TOUR

Having a guide show you the local specialties (at home or abroad) gives you a break from research, and provides a fresh perspective and new knowledge. You can create your own tour by using a favorite food to map your route through a city; shops with great pastry is an itinerary I love to follow. Get to know a neighborhood by visiting every eatery in the area and photographing your progress.

@LaureJoliet

Laure Joliet
laurejoliet.com

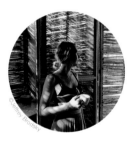

Laure Joliet is a Los Angeles–based photographer with an eye for living things and lived-in spaces. Her images are intimate, inviting, and unpretentious—they immediately convey the fundamental magic of spaces lit mostly by the sun.

♥ inspiration

I'm always curious to see new places, meet new people, and capture the quirks of how they live—this spirit is what drives how I photograph. My passions inform my subject matter!

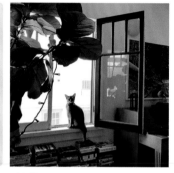

♥ tip

When shooting a beautiful room with your phone, make sure to tap the shadows so that your exposure adjusts—it will normally brighten up the whole image and make the room feel dreamier and truer to what you are seeing with your eye.

♥ approach

I show up with a curious attitude. I don't overplan— I have a loose framework for parts of town, restaurants, stores, and sights I want to see. I try to leave enough time for the unexpected.

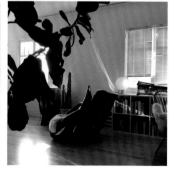

♥ challenge

I mainly use phone shots for Instagram, so the biggest challenge can be the phone shortfalls. Shooting in low light can be frustrating, as can loving a shot and wishing I had it as a larger file. But overall I am so grateful for my phone.

♥ adjustments

I like to bump brightness a touch, add contrast, sharpen a little. It makes the image feel crisp but still real, and just helps to define it on the screen.

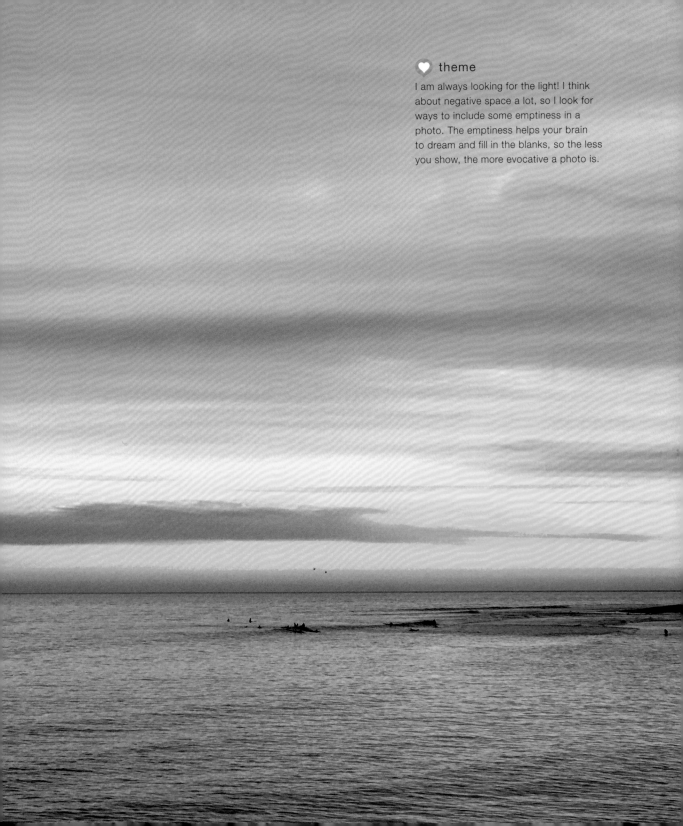

I am always looking for the light! I think about negative space a lot, so I look for ways to include some emptiness in a photo. The emptiness helps your brain to dream and fill in the blanks, so the less you show, the more evocative a photo is.

HACKS AND TIPS

ALWAYS ON • DON'T STRESS THE START
EASY ADJUSTMENTS • BRING THE FUN
SHOOTING IN BLACK AND WHITE
EQUIPMENT HACKS • WHAT NEXT?

ALWAYS ON

You always have the most important pieces of equipment with you—
your brain and determination. If you don't have your camera, use your
phone; if you don't have your phone, borrow one from someone
standing next to you and e-mail the images to yourself.

1 **THE TOOL IS IRRELEVANT**
The cameras in our phones are capable of capturing
complex images full of luminosity and detail. Entire
magazines are being shot with iPhones (*Bon Appetit*,
among a host of others), so there are no excuses not
to try if you have an interest.

2 **DOWNSIZE THE CAMERA, UPGRADE
THE PHONE**
An older phone can produce great shots, but
technology upgrades and slow performance can
interfere with its function. When the time comes to
upgrade your equipment, buying a new camera is not
necessary. Upgrading your phone is a less expensive
way to improve the quality of your pictures and access
the latest technology.

3 **CAPTURE THE UNUSUAL**
Stay as alert and present as possible, all day, every
day. Once you train your eye you'll notice so many
more out-of-the-ordinary moments. It won't take
long for you to start finding extraordinary ways to
capture the mundane, either. Train the eye and the
rest will follow!

DON'T STRESS THE START

It will take time to get the shot you want. Regardless of the subject, the magic shot is always caught somewhere in the middle of a session— at the sweet spot where everyone is relaxed, and there is a sense of partnership between photographer and subject.

1 SET EVERYONE UP FOR SUCCESS

Make sure everyone you are photographing is well fed, physically comfortable, groomed, rested, and happy with the music playing. If you are photographing fashion, make sure that clothing is free of logos and comfortable to move in. Having these basics down before you begin will help bring everyone into the moment and make them ready to create a timeless image. These preparations can also provide an opportunity for some great spontaneous shots.

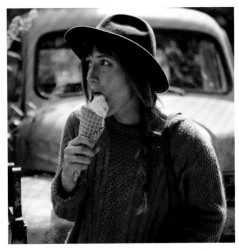

2 SLOW DOWN

Pace yourself; take some deep breaths before, during, and after a shoot. Encourage everyone around you to do the same. Stretch a little, take a bathroom break, look in a mirror and say to yourself, "You got this" (it's cheesy but it works). Direct, breathe, review, readjust, tweak, laugh, then repeat the cycle all over again.

3 ENCOURAGEMENT

I start with a ton of compliments for all of my subjects. It's a genuine approach and makes people relax and feel good. I'll say something like, "I love your outfit! It's going to look great with this background I picked for us." Or, "You're going to make my job easy, you look gorgeous." This approach lessens a subject's expectation of feeling awkward in front of the camera and sets a positive tone for photographer and subject.

EASY ADJUSTMENTS

One person can look at an image and think, there's too much contrast; another may feel the same image is snappy. What is most important as a photographer is to understand your own style and preferences; try everything until you arrive at what you like best.

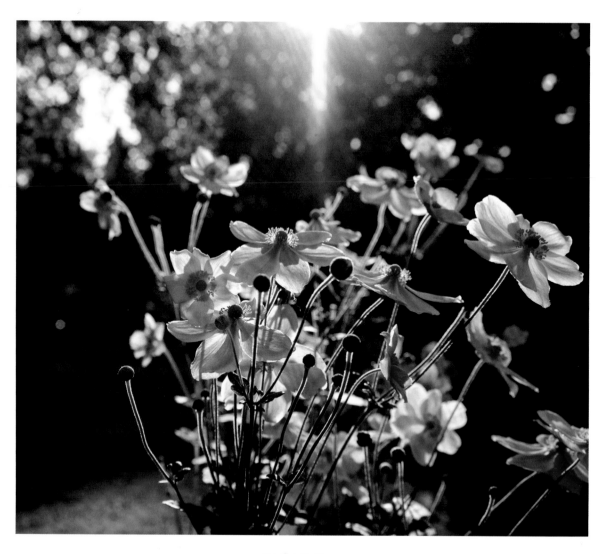

*I bump up the brightness
very slightly to add luminosity
and joy to an image.*

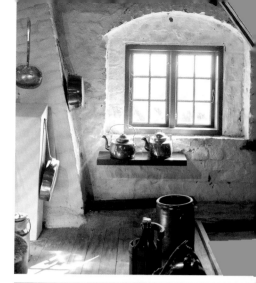

1 CONTRAST

What the camera sees is often a smidge flat to my eye. I like to counter the uniform, slightly dull look by increasing the contrast. The trick here is not to go overboard; a little tweak to contrast went a long way to making this rustic kitchen interior pop. Start by dialing the contrast all the way up and then bring it back until you get it where you want—just a little better than in camera.

2 BRIGHTNESS

Unless I am shooting a "dark and moody" look, I bump up the brightness very slightly to add luminosity and joy to an image. Take care not to overdo this adjustment, though; it can blow out the lighter parts of your images.

3 SHADOWS

Adding light to shadows will reveal more information in the picture plane (details of the trees surrounding the building); adding darkness will make the image more dramatic. Pick what works for you. I go both ways, depending on the image.

4 ROTATE

Use the rotate tool on architectural or interior images to get vertical and horizontal lines straight. An adjustment of just two to five degrees can make all the difference.

5 HIGHLIGHTS

The highlight tool is useful when you've shot in bright sun, such as a scene of boats in a marina, or had to expose for a medium part of the picture plane. When areas of an image are too bright and lack detail, you can add visual information in those zones by bringing the highlights down.

BRING THE FUN

You cannot underestimate the power of a silly attitude,
an outgoing vibe, and a few simple tools to get a photo shoot
going smoothly. Atmosphere is everything—the tone you
set is key to creating succesful images.

① MUSIC

Music is always a good means of loosening people up.
I love to create a playlist that goes with the mood of
the shoot—if I'm shooting a French floral tea party,
I'll find 60s French female singers and make a playlist
that lasts for a couple of hours. For a portrait shoot,
I love Motown; it makes everyone feel awake. Kids
love show tunes (I do too), which makes it easy for
everyone to sing!

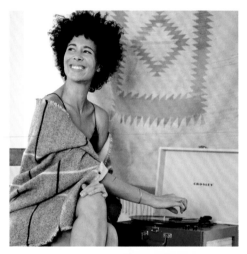

② BE THE CIRCUS CONDUCTOR

How many photographers does it take to move
a light bulb? Answer: It's irrelevant. The point is,
the light bulb needs to be wherever you think it
looks good on the subject. Maybe it's switched
off altogether. You're the conductor. You have to
direct. Don't be passive.

③ CHAT THEM UP

Banter like "You've modeled before, haven't you?"
makes everyone giggle. The stupider the chit chat,
the better. "Work with me baby, work with me!" is
my all-time favorite (I got it from my photographer
father). Keep talking. Keep shooting. Have your subject
look away from the camera and then again toward
you. People love being treated like a glamorous
celebrity. Help them live in this illusion.

SHOOTING IN BLACK AND WHITE

Black and white abstracts, imbues nostalgia, and flattens a scene.
It simplifies, but it is far from boring. There's a romance to it that
can't be topped. Color is *Amelie*, black and white is *Casablanca*.
It makes subjects appear timeless.

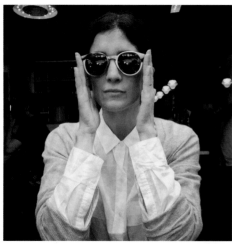

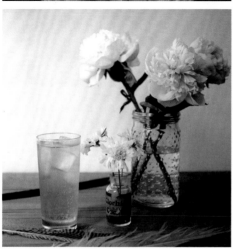

1 LOOK FOR CONTRAST

When composing for black and white, think in
extremes: strong blacks and bright whites. This will
help capture tones between each end of the tonal
spectrum and keep the picture plane interesting.
A woman in a white shirt wearing sunglasses and
standing in front of a dark background has the
ingredients for making a beautiful black-and-white
image. When composing in black and white, shoot for
the shadows to avoid losing them. This can blow out
the highlights, but they can be recovered in post.

2 TONE AND TEXTURE

Instead of looking for contrast, focus on subtle shifts
in tone. Removing color removes distractions and
increases the visibility of slight shifts in shades of
gray. This also has the effect of increasing a viewer's
awareness of texture.

3 THINK TIMELESSNESS

Timeless subjects are strong choices when
shooting in black and white—still lifes, family
portraits, historic sites. A dramatic lighting
pattern will emphasize graphic shapes in the
shadows and produce pretty highlights.

EQUIPMENT HACKS

There is not much needed to start making amazing images other than a phone
or camera. I wouldn't run out and buy a thing. Chances are, all the tools you
could want can be found around your house. With a little preparation and
ingenuity, you can set up a mobile photography studio in no time.

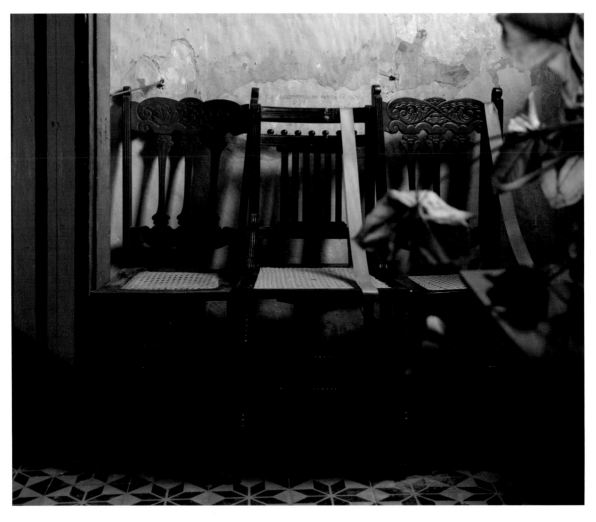

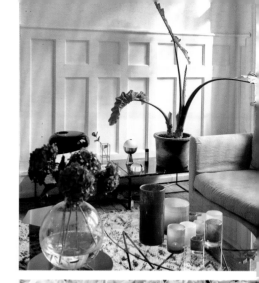

1 BODY TRIPOD

If you have a wall, you have a tripod. Brace your back against a wall, squat slightly, and push into the surface with your back, making a chair shape with your legs. Now you have a steady position to shoot from. Your forehead is pretty flat. It may look funny, but put your phone against your forehead. Take a deep breath and shoot (this will steady the shot, keeping things in focus). Your shoe can also be a great tripod; a camera or phone nestled in a shoe is secure and shake-free.

2 REFLECTOR CARD

Anything white or light colored can become a decent reflective card. Even a white shopping bag can bounce light onto a display of flowers—ask a friend to hold it up. You can throw a white T-shirt over a piece of cardboard or even ask someone wearing a white T-shirt to stand next to your subject, opposite the light source.

3 MACGYVER ANYTHING

With an attitude that there is no problem that can't be solved and a refusal to say, "I can't do that", there is always a solution to be found. Duct or gaffer tape are incredible inventions; tape your phone to a wall or mirror, set the timer, and—boom—jump into the shot. The headphone volume button on your headset is a remote shutter when you are in your phone's camera app. Just turn up the volume to "snap" a picture. Add a tiny drop of water to your lens for a hazy effect, then clean up right away to prevent damage. Chat to other photographers; learn from everyone about hacks and fixes you can incorporate into your photographic process.

4 SUNGLASSES AS POLARIZING FILTER

On a very bright day in a location that has tons of lights and darks, it can be helpful to tone things down with a filter. I use my sunglasses by putting a lens right in front of the phone's lens. This tones down the brights while maintaining the saturation. You can then boost the overall brightness in post, taking care to keep the highlights in check.

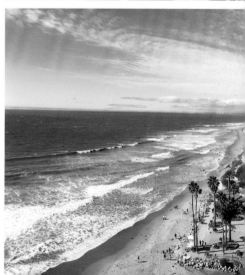

WHAT NEXT?

I'm not sure where photography and Instagram are headed. What I am sure of is that every wave of technology is exceeded by something new and different, almost as soon as it arrives. The only constant is change and evolution. What doesn't change is that the cream still rises to the top; those who have interesting, curious ways of tackling creative problems and coming up with unexpected solutions are the ones who push the medium forward. This evolution doesn't always come from the people designing the tools. Rather it's a conversation between artists, makers, technologists, and the audience that moves imagery and the way we view it forward.

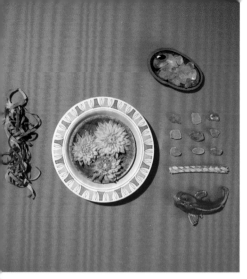

Staying nimble and on your toes creatively will help you evolve along with the technology.

1 STAY NIMBLE

The most important thing to keep in mind when making images and pushing them out to the world via Instagram is to not get complacent. You cannot be successful doing the same thing day in and day out. Be flexible and make choices that are uncomfortable. Staying nimble and on your toes creatively will help you evolve along with the technology—your portfolio will thank you, and this attitude will lead to a more interesting life.

2 KEEP ENGAGING

The easiest way to get out of a rut and burst through to a reinvigorated style, point of view, or creative beat is to keep engaging with others in your field. If you are a photographer, reach out to an interesting stylist for the jolt of new ways of seeing. Talk to art directors about where they see your work headed. Pair up with a farmer to shoot their land, the food they grow, the home they live in—the pictures will be a lovely thank you to the farmer for their help in leading you to a renewed sense of creative purpose.

3 EARLY ADOPTERS

Don't get bogged down by technology, but stay engaged and relevant. It's not the medium that defines amazing artists; it's their creative approach to working in and being curious about the new tools available to them. David Hockney's artistic career has seen him work in classical drawing and painting, photo collages, video, and digital paintings done on an iPad. Don't begrudge changing technology—figure out how to make it work (and make it fun) for you in your artistic practice.

GLOSSARY

AFTERLIGHT
An image-editing app for iOS, Android, and Windows. Using inbuilt tools, filters, customizable textures, borders, and frames, it allows you to create unique mobile photo edits quickly and easily.

ARTIFICIAL LIGHT
Light supplied by lamps or lighting rigs to produce various effects. Can be used to replicate natural light or to introduce a specific aesthetic effect.

ASPECT RATIO
The proportional relationship between the width and height of an image. Instagram's original square format was a 1:1 ratio.

AVAILABLE LIGHT
Also known as "ambient light" or "natural light." The light available in a setting without the addition of artificial sources.

BLOWN OUT
Overexposed highlights that are all white and lack detail.

BOUNCE CARD
A reflective piece of card used to help direct and soften the light from the sun or an artificial light source.

CHIAROSCURO
An oil painting technique developed during the Renaissance, in which strong contrasts are used to create drama and to give objects 3-D form.

COLOR CAST
A tint of a particular color across part or all of an image. Artificial light setups can create an orange or yellow cast. Applying a blue filter can reduce an orange or yellow cast. An amber filter will balance a blue cast.

COMPOSITION
The placement and arrangements of elements within a photograph.

CROPPING
The removal of areas of an image to improve the framing and highlight the subject.

DEPTH OF FIELD
The distance between the closest and farthest points at which an object is in focus. Can be used to direct a viewer's eye to certain elements in an image.

ESTABLISHING SHOT
An image used to set up or explain the context of a series of images.

EXPOSURE
The amount of light received by the sensor of a camera via the lens.

FIGURE-TO-GROUND RELATIONSHIP
A clear distinction between the subject (figure) and the background (ground); a light subject on a dark background, or a dark subject on a light background.

FRAME(ING)
The placement of the subject(s) in relation to other elements in an image.

GOLDEN HOUR
Also known as the "magic hour," the golden hour takes place during the first hour of sunlight in the day, and the last hour before the sun sets. It is known to be one of the most favorable times to shoot because the light from the sun is softer and creates a warm glow.

HARD LIGHT
A light source that creates hard, crisp-edged shadows.

LANDSCAPE MODE
An aspect ratio where width is greater than height.

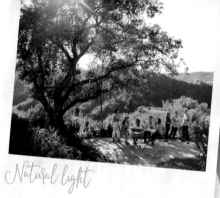
Natural light

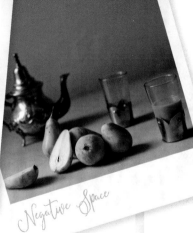
Negative Space

LIVE VIEW
A digital camera or phone's ability to display an onscreen preview of the image in front of the lens.

MACRO
A mode on some cameras (or a lens) used to capture extremely close-up details of an object.

MUSE
Traditionally, an inspirational goddess of Greek mythology. Used generally to describe a person who provides creative inspiration to an artist.

NATURAL LIGHT
See available light.

NEGATIVE SPACE
Also called "white space," the space around and between the subject(s) of an image. Negative space gives the eye a place to rest and can highlight the subject(s).

PERSPECTIVE
The relationship between the size of objects within an image and their distance from the eye or the lens. Distant objects appear smaller, while parallel lines appear to converge.

PHOTOSHOP
An image-editing program for Macs and PCs. The industry standard since 1988, the name has come to be synonymous with digital editing.

PICTURE PLANE
The surface in the foreground of an image that corresponds exactly with the material surface of the image—the point of visual contact between the viewer and the picture.

POINT OF FOCUS
The object in a photo that is most in focus, and to which the eye is naturally drawn.

PORTRAIT MODE
An aspect ratio where height is greater than width.

POST
Adjustments made to an image after it is taken.

SCRIM
Fabric used to diffuse light.

SHOT LIST
A checklist of images. Used to ensure a range of subjects, poses, locations, framing, and scale.

SOFT LIGHT
Light that produces soft, diffused shadows that appear to wrap around objects—created by cloud cover, or with the use of a scrim to filter the light.

SUBJECT
What is shown in a photo.

TONAL RANGE
The difference between the lightest and darkest areas of an image.

VIGNETTE
An image where the edges have been softened, feathered, or blurred.

VSCO
An image-editing app for Android and iOS, with superior filters (called presets) and granular editing tools (to adjust tone, saturation, etc.), which connects to its own publishing platform, Grids. VSCO allows you to take, edit, and share photos, all from within the app (#vsocam).

INDEX

Pancake perspective

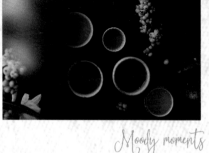

Moody moments

Leela Cyd

Leela Cyd is a photographer and author living in Santa Barbara, California. She lives a block from the ocean with her husband David, and son Izador. Leela's work centers around the intersection of imperfect beauty, beloved travels to far-off places, colorful styling, food stories, and joyful moments at the table with friends. She shoots and writes wherever she goes, often for publications such as the *New York Times*, *Kinfolk*, and *Sweet Paul*. Leela has also photographed and authored three cookbooks: *Food with Friends*, *Tasting Hygge*, and *Cooking Up Trouble*.

@leelacyd
leelacyd.com

 thank you

I would be nowhere without the lively bunch I hold close around me—the people who make my days worth noting.

 thank you

I am grateful to my parents, Richard and Cissy, for encouraging me to work on this book and to share my story—and for all their babysitting to allow me time to write. You embolden me to reach higher than I think I can go.

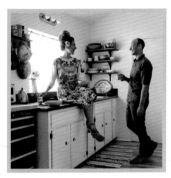

thank you

Gratitude to my big brother Nick, who with his humor and upbeat take on life teaches me to enjoy the ride.

 thank you

To my husband David, for more than a decade of helping me to unfurl my creative wings, and his unfailing patience while I'm getting a shot on my tippy toes in some far-off place.

thank you

Biggest thanks of all to Izador Cosmo, my son—you came into my world, charmed me silly, and I found my favorite subject for ever and ever.

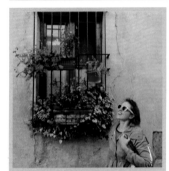

 picture credits

The publisher would like to thank Shutterstock.com for permission to reproduce their images:
iPhone by Zeynep Demir, 4–5, 7, 9, 51, 93, 130–133, 171, 176–177
Flat lay by Arkhipenko Olga, 28–29
Flat lay by Volodymyr Hlukhovskyi, 176–177

 contributors

Unless otherwise noted, image ©:
Aran Goyoaga, 36–37
Marioly Vazques, 52–53
Joya Rose Groves, 80–81
Sam Zucker, 88–89
Anne Parker, 98–99
Sanda Vuckovic Pagaimo, 142–143
LaTonya Yvette Staubs, 154–155
Jonny Kennedy, 164–165
Laure Joliet, 174–175